LORETTE WILMOT LIBRARY
Nazareth College of Rochester

Rochester City Ballet

Stars of the Twenties

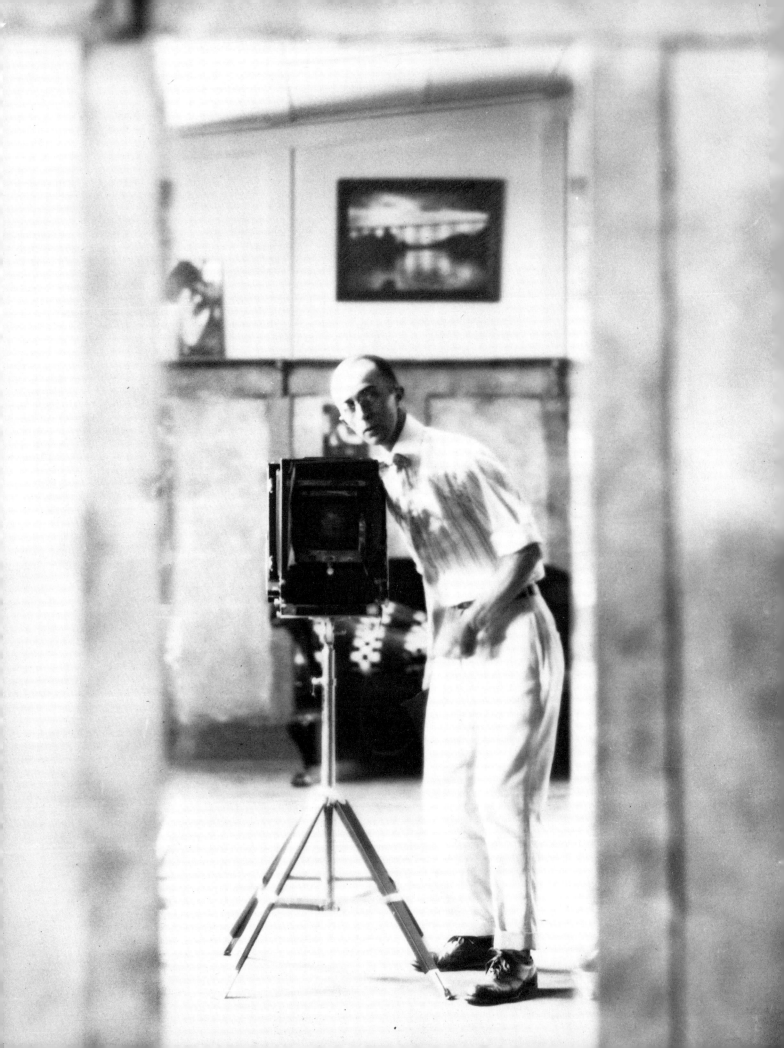

Stars of the Twenties
Observed by James Abbe

Text by Mary Dawn Earley
Introduction by Lillian Gish

A Studio Book · The Viking Press · New York

Frontispiece: The photographer in his studio

First published in 1975 by The Viking Press, Inc.
625 Madison Avenue, New York, N.Y. 10022

Published simultaneously in Canada by
The Macmillan Company of Canada Limited

SBN 670-66836-2

Library of Congress catalog card number 74-29487

Printed in U.S.A.

Introduction

In the early 1920s James Abbe had a highly successful studio in Tin Pan Alley, where his personal photographs of prominent people brought him a large clientele.* We met for the first time when he asked me to come to his studio to pose for him after the opening of *Broken Blossoms* at the George M. Cohan Theatre. D. W. Griffith had moved his company East after buying the old Flagler estate on Orienta Point, a peninsula jutting out into Long Island Sound at Mamaroneck, New York.

When I went to see Mr. Abbe, I found him to be a charming Southern gentleman who shared my interest in photography. Abbe also believed that photographers, instead of using oils or watercolors to paint faces, could get the same effects by painting the face with lights. The hard work of manipulating and focusing his lighting equipment gave his photographs beauty and life. He was such a little man—he couldn't have weighed more than a hundred and ten pounds—and he looked so undernourished that one's first instinct was to take him out and buy him a substantial dinner. Instead, I almost drowned him.

After the completion of the new studio, Mr. Griffith's first picture there was *Way Down East*. Abbe came out to shoot some of the still photographs. One day, during lunch hour, I was teaching myself how to swim. When I swallowed salt water I was inclined to panic, so I put a clothespin on my nose to make me breathe through my mouth. When Abbe swam around the far side of the pier and discovered this odd sight, he burst into sudden laughter, swallowed lots of salt water, and almost drowned.

My beloved sister, Dorothy, and I both posed for him at his New York studio while we were making what was to be our last picture for Mr. Griffith, *Orphans of the Storm.* Dorothy then went to Cuba to film *The Bright Shawl* with Richard Barthelmess, and I, along with Henry King and twenty-two others, sailed for Europe to make the first American film in Italy, *The White Sister.* To our great surprise Abbe accepted our offer at probably one-tenth of what he was earning to go with us. An addition to our company was Polly Shorrock, on an assignment from the *Ladies' Home Journal* to write an article on the filming of this first modern religious story.

The fully equipped studio we were promised in Rome turned out to be an empty building unused since World War I, containing two little klieg lights,

* Tin Pan Alley referred to the New York City block on 47th Street between Seventh and Eighth avenues occupied by musicians, music publishers, instrument dealers, and others in the music profession.

the only two in all of Italy. We put our electrician on the next night train to Berlin to get equipment. Abbe was amused by the fact that he was cast to play the small part of Lieutenant Rossini, but this did not keep him and his camera from taking full advantage of the overwhelming beauty of our new surroundings. We also shared the excitement of discovering with our cameraman, Roy Overbaugh, that the actinic rays of the sun in Italy were different from any that we had worked in, which led to new, subtle, and amazing differences in our treatment of film. This began our experiments with panchromatic stock. Abbe built his darkroom in the corner of the studio, and out of it poured hundreds of arresting photographs that helped *The White Sister* make millions of dollars around the world.

During this period a romance blossomed between Abbe and Polly Shorrock. Instead of returning when we finished, she mailed her article back to New York and remained in Europe. After their marriage they joined Dorothy in England, where she was making films for Herbert Wilcox. Abbe's pictures of her in *Tip Toes* with Will Rogers and Nelson Keys and of her in *London* are among her loveliest *(see Plate 80)*.

In the 1930s both Dorothy and I returned to the theater, while Abbe remained abroad. Our paths were not to cross again until 1972, when a friend of mine who works for *American Heritage* sent me a copy of their magazine with an article on Abbe. One photograph labeled "Dorothy Gish" happened to be of me. When I pointed this out, shortly thereafter came an endearing letter from Abbe: "As I loved the Gishes equally, I could never tell them apart."

In the fall of 1973 I was in San Francisco on a tour to help sell our book, *Dorothy and Lillian Gish.* I called Abbe, hoping we could lunch together, only to hear his voice, full of energy, complaining that he was confined to his bed, of which he did not approve. He promised that nothing would stand in his way for our meeting the next time I came West. He left us a few days later. We are grateful that the world seems a little better for his having lived in it, and now we have this book—his legacy of character and beauty.

<div align="right">Lillian Gish</div>

New York City, 1974

James Abbe

"My early feeling about the power of the camera was that it was my own Aladdin's lamp . . . like having a personal genie that could take me anywhere." And for James Abbe, photographer of the great and near-great on many continents, the camera had that magic. Always fascinated by action and movement, he was possibly the first to capture candid spontaneity in photographing celebrities. Of the cumbersome view camera he used back in the twenties, Abbe later said, "Because of the necessary time exposures, I'd frequently resort to the Mathew Brady technique of virtually hypnotizing my subject while I exposed the film." His photographs of Katharine Cornell, Fanny Brice, Marion Davies, Tallulah Bankhead, Ann Harding, and many other famous personalities reveal how successful he was in capturing his dream of suspended action.

Abbe went on to combine writing with photography and to become a pioneer in photojournalism. From there it was a natural step to war correspondent, radio news commentator, and television critic. It is the Abbe portraits of the twenties, however, that bring us today all the shining brightness of his special talent.

James Abbe grew up in Newport News, Virginia, although he was born in 1883 in Alfred, Maine, from a long line of Yankees. Son of a bookstore owner, he never received a high-school diploma, but early on developed a passion for photography. One day in 1895 a beau of his older sister Nellie, named George, arrived at the family house with a small black object called a Kodak. George said he could take photographs out-of-doors with the little black box, then develop and print them himself. Immediately fascinated, young Abbe readily accepted the loan of the magic box as a bribe to keep out of the way while George courted Nellie. George and Abbe then persuaded Abbe's father to apply for the Kodak agency, which he obtained, and it was a money-maker at Abbe's Bookstore for many years. Abbe became adept at photographing the launching of battleships at the nearby shipyard, and after his final shot of such a launching, he would bicycle with the camera to Abbe's Bookstore. There a versatile clerk removed the film, developed and force-dried it. Then the gang would team up to print postcards, which they sold on the sidewalk in front of the store to people returning from the launching. At ten cents apiece

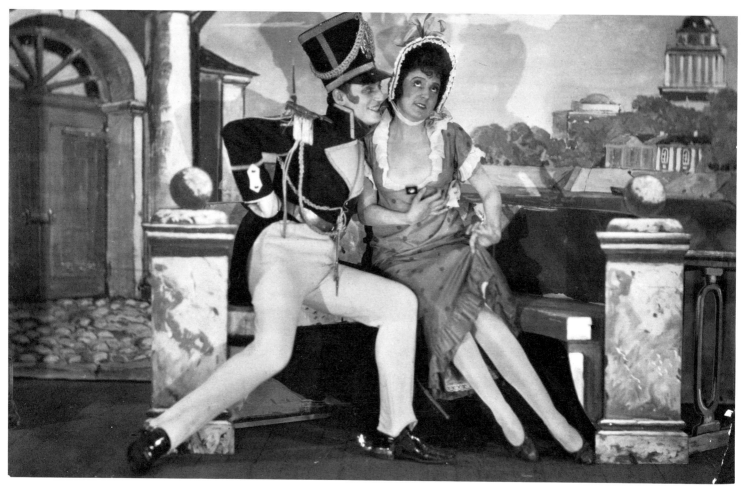

Two of Moscow's *Chauve-Souris* performers during an appearance in New York

they would average two hundred dollars the first day and one hundred dollars for several days thereafter.

In February 1898 Abbe rode out on the James River, loaded with Kodaks to sell to sailors aboard the battleship *Maine* before her departure for Cuba. He sold several hundred dollars' worth, shot groups of sailors aboard, then rowed around the ship, shooting her from various angles. Soon afterward, the *Maine* blew up in Havana harbor, and Abbe's pictures immediately became valuable, even though at that time not a single newspaper in the United States was printing photographs.

But when William Randolph Hearst took a camera with him on his yacht to the Spanish-American War, his magazine *Cosmopolitan* published the photographs later in the year, and the Hearst newspapers soon followed. The photo-reporter era had begun.

Some years passed, however, before Abbe made a name for himself as a photojournalist. In his first job in 1913 he photographed college girls for the annuals published by the highly respectable J. P. Bell Company of Lynchburg, Virginia. The knees and thighs so freely exhibited by the present generation were only dreamed of then, but the girls themselves were no different. When

Abbe impulsively photographed an impromptu ballet group performing in their homemade costumes, he was inundated with requests for individual poses. After the austerity of photographing graduation groups, the freedom afforded by this new work inspired him, and he was flooded with orders for prints, enlargements, and framed copies. After he had gained considerable professional experience and had acquired a wife and three children, he decided it was time to head north and try his luck in New York City. The year was 1917, and he was thirty-four years old.

After he rented a studio on West 67th Street, it did not take Abbe long to become known. He peddled his photographs of college girls, selling them at five dollars apiece to illustrate fiction stories. Then the *Saturday Evening Post* and the *Ladies' Home Journal* asked him to submit some of his work. One of the photographs, of Jeanne Eagels, was accepted by the *Post* for seventy-five dollars. It was the first time the *Post* had ever used a photograph on its cover, and it made magazine history. Abbe was off and running.

Many famous stars of stage and screen sat for him during the years he lived on West 67th Street, where he worked only with daylight and used mirrors to reflect light into shadowed areas. However, it was John Barrymore who,

Mack Sennett comedians Ben Turpin and Phyllis Haver

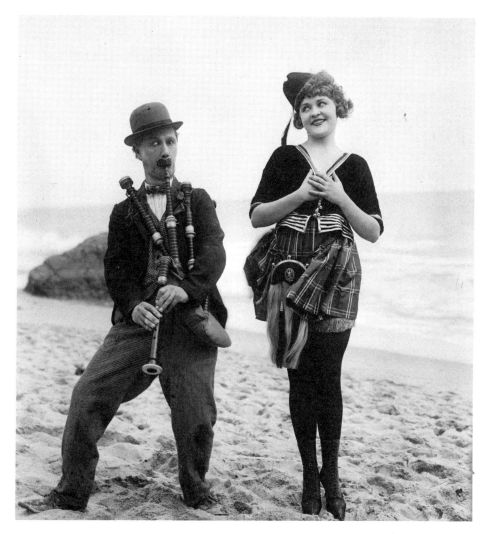

by refusing to pose for publicity stills in the studio, caused Abbe to open a new field in stage photography. The star was rehearsing *The Jest,* in which his brother Lionel was also appearing, at the Plymouth Theatre. John Barrymore argued, somewhat sarcastically, that it was foolish to shoot pictures of performers in costume in a studio, and that if a photographer had any imagination he'd learn how to shoot in the theater, on the stage, with the sets and props. That was all the invitation Abbe needed. He persuaded the producer, Arthur Hopkins, to provide the full stage crew, including electricians, and portable thousand-watt lamps, to run overtime for four hours following a rehearsal, and it paid off. The papers and magazines went wild over the pictures, and *The New York Times* adopted Abbe as its stage photographer. From then on virtually every show that opened on Broadway gave him the exclusive shooting rights on stage.

Several years later, when Barrymore was playing *Hamlet* at the Royal Haymarket Theatre in London, he gave Abbe a warm welcome, although he refused to pose for any English photographers. Barrymore sent out for a bottle of Scotch, which he insisted Abbe share with him. Abbe, not wanting to risk any part of his exclusive, protested that he couldn't be sure of his photography unless sober. "That's ridiculous, Abbe," Barrymore responded. "You've been working at a disadvantage all these years. With Scotch like this you will outdo yourself." And so he did.

In 1919 Abbe moved from West 67th Street to his Tin Pan Alley studio, on West 47th Street, which he outfitted with motion-picture lights like an undersized movie studio. His neighbors were Irving Berlin and the ex-champion heavyweight of the world, Jack Johnson. His subjects were those glamorous figures of stage and screen who became the first truly world-famous stars: Theda Bara, Pola Negri, Lillian Gish, Mabel Normand, Billie Burke, Mae West, Rudolph Valentino, and they all breathed the same magic word to Abbe— Hollywood. When D. W. Griffith said he thought the photographer should visit the film colony, Abbe decided to do so.

With his New York reputation preceding him, Abbe had no trouble finding work in Hollywood. One of his first assignments was to photograph Mary Pickford. She was making the film *Suds,* and he was to shoot the stills. Always the perfectionist (although she had just finished a full day's filming and it was her birthday), "America's Sweetheart" posed for many hours until both she and Abbe were satisfied. It was during this work session that Mack Sennett asked Abbe to take some stills of his bathing beauties (only three of the fourteen could swim), and later invited him to try directing a movie. Abbe asked innocently, "How about a script?" and was told, "We never have scripts here, never story lines; nothing is written down. Our directors"—Sennett had five of them—"are paid to have an idea for a two-reeler to start with and to be able to stage and direct their scenes." Abbe concocted a piece about goings-on in Greenwich Village that mixed love and slapstick, suspense, surprise, and a

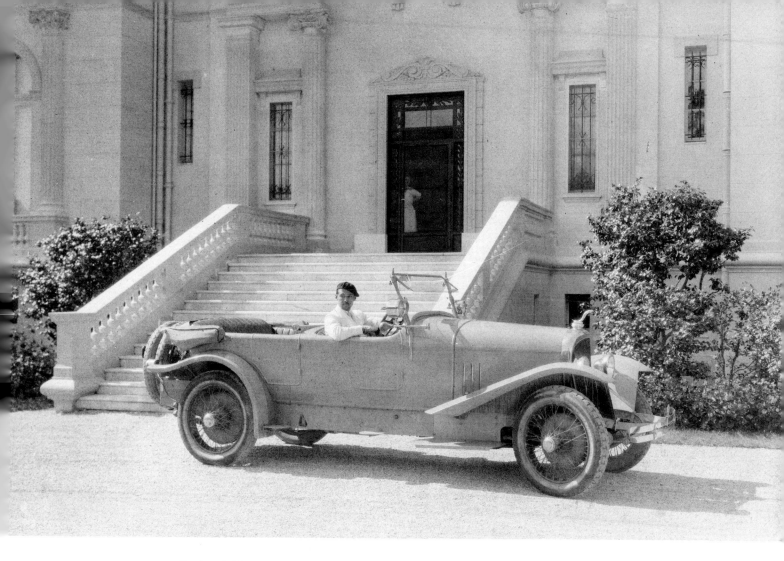

Rudolph Valentino, parked in front of the Hudnut Château, France

few other ingredients. The result was never shown, but it impressed Sennett (and his assembled directors) enough for him to offer Abbe a job. Before Abbe could answer, Sennett added, "Come tomorrow with your own idea of a story," and walked away. Elated by the experience, Abbe appeared the next day, having racked his brains and finally decided on a slapstick version of Kingsley's *Water Babies,* incautiously adding, "Let's inject a little subtle comedy into slapstick." Sennett shook his head sadly. "Abbe," he said, "there is only one basic comedy situation in life—a kick on somebody else's shins!"

In Sennett's stable of bathing beauties at that time were several unknowns destined for stardom, including Carole Lombard and Gloria Swanson, all duly photographed by Abbe.

Soon after he returned to New York, following his fling in Hollywood, Abbe was shooting publicity stills for D. W. Griffith in his Mamaroneck studios. The two greatest female screen idols of the time (1922), Dorothy and Lillian Gish, were frequent subjects and soon became Abbe's friends. After a session at his studio one day, Lillian, or "Miss Lillian," as he always called her, asked if he would like to join her company as still photographer on the movie *The*

White Sister in Italy. Abbe was immediately interested. Miss Lillian also mentioned a problem facing the company at that moment. They lacked a leading man, would like an Italian if possible, and did Abbe know of anyone? Abbe called Valentino in Hollywood, who, he knew, regarded Lillian Gish as the greatest of screen actresses. Unfortunately, Valentino's contracts would not permit him to take the time. Abbe searched New York's leading theaters, finally winding up in the Empire, where Henry Miller and Ruth Chatterton were playing in *La Tendresse.* The second male lead was a young unknown recently arrived from the London stage. Abbe decided he had found his man. He called Miss Lillian, who called her director, Henry King, and cameraman Roy Overbaugh, and then joined them with a movie camera in his studio the next day for a test. The young man did well and was invited to join the company to play his first movie role. He accepted. His name—Ronald Colman.

Within a week the company sailed for Naples—an excited group of about twenty. Mary Pickford came over to Brooklyn to see Lillian off at the pier, as did Abbe's three children—Elizabeth, Phyllis, and Jim, Jr. Their mother and Abbe had separated, and he left New York never to retrace his steps.

The company traveled to Rome, Tivoli, Frascati, Sorrento, and even across the Mediterranean to Tripoli. As a result of this unexpectedly long

Yvonne Printemps and Sacha Guitry

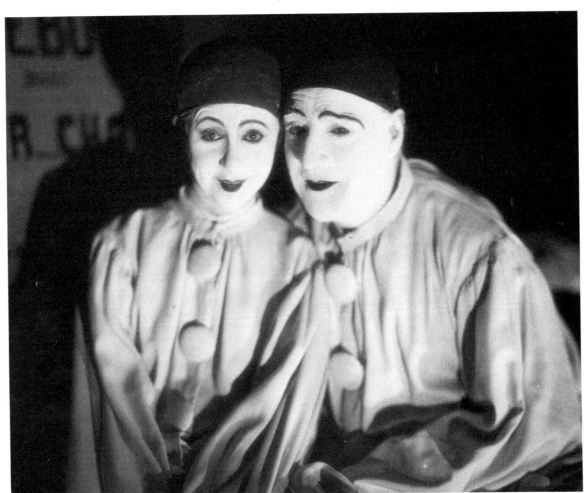

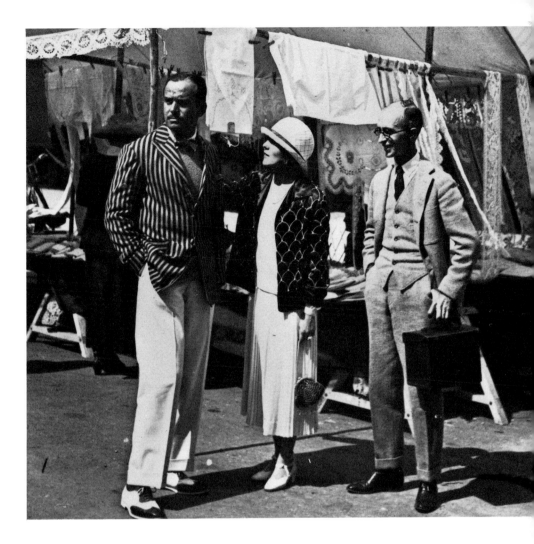

Douglas Fairbanks, Sr., Mary Pickford, and James Abbe

itinerary, the filming of *The White Sister* took seven months rather than the scheduled three. King, the director, thinking that Abbe looked the part, cast him in the role of a dying soldier in a desert scene in Africa. Since it was a silent movie, Colman, like any other silent actor, could actually say whatever he wanted. So as Abbe lay presumably dying, he said, "To think that I should have to play a scene with a still photographer."

In 1923 Paris was ripe for stage photography, and Abbe was ripe for Paris. After completing the film in Italy, falling in love and remarrying—a former Ziegfeld beauty, Polly Shorrock—Abbe headed for the French capital, his home for the next eight years. His studio was in an ancient cluster of houses on the rue Val-de-Grâce that dated back to Louis XV. During the winter months the big stove in his studio warmed many a subject. One particularly lovely visitor was Bessie Love, top-flight American movie star. The Dolly Sisters, Rosie and Jenny, at the peak of their success, came too. They had taken over the Moulin Rouge with an expensive song-and-dance girlie "spectacle" that sold out for months. The Hungarian-born Dollys, who achieved fame in New York and then settled in Paris, parlayed their talents to international heights, being astute businesswomen as well as publicity-minded and photogenic performers. Throughout the twenties they were the toast of Paris and London. It was the Dolly Sisters, along with superstar Mistinguett and

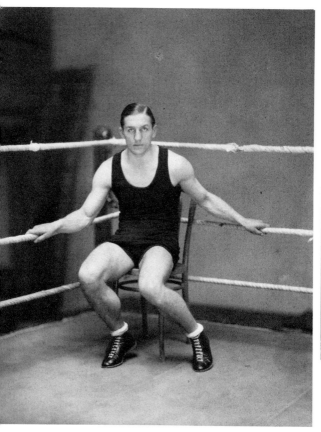

Georges Carpentier

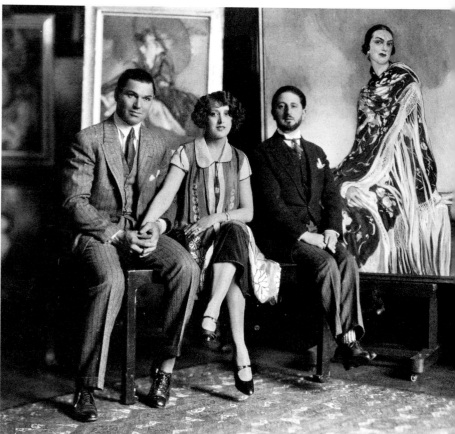

Jack Dempsey, Estelle Taylor,
and Jean Gabriel Domergue

actor Sacha Guitry who launched Abbe in Paris merely by letting him photograph them in their respective shows.

Old friends from the States were always turning up in Paris: Chaplin (whom the French adored and called "Sharlee"), Marc Connelly, Jack Dempsey, Gilda Gray, Al Jolson, Mary Pickford and Douglas Fairbanks, the Gish sisters, Fred and Adele Astaire, and many others. The Astaires posed in Abbe's Paris studio and later again on the stage of the Prince of Wales Theatre in London.

In 1924, while visiting London, Abbe also photographed Noël Coward and Gertrude Lawrence in a musical variety show, *London Calling,* written by Coward. These were the first stage photographs done in the Abbe style in London. The editor of the *Tatler,* who published them, was so impressed that he offered Abbe a permanent job. Despite the tempting offer, Abbe declined, since he was still enamored with Paris. However, he did spend time commuting to London on special assignments. After a session with Coward and Lawrence, as they wound up at 3 a.m., Beatrice Lillie dropped by with the Astaires. Lillie herself was enjoying a tremendous hit doing her hilarious cockney waitress routine at one of the music halls and was about to depart for her first try at the New York stage. The Astaires suggested that Abbe photograph her on stage and send the pictures over to the States ahead of

her. They were published in New York, and after New York's first look and laugh at this new British comedienne, her success was assured.

Meanwhile Coward had a pressing problem concerning the States. He, too, wanted to try his luck in New York and had written some plays and sketches to take over and try to sell. He quizzed Abbe and the Astaires: "I have enough money to stay a month at the Ritz, or probably enough to hold out for three months at a cheaper hotel. Which way should I play it?" Abbe recommended the Algonquin, but the Astaires favored the Ritz. It was many years later that Abbe found out that Coward had followed the Astaires' advice and stayed at the Ritz but had not sold the plays. Not then.

On a later visit to London Abbe was assigned to shoot the stills of a movie starring Dorothy Gish and Will Rogers. When Abbe showed Rogers the proof, Rogers asked, "Do you think that does me justice?" Abbe replied that he didn't know it was "justice" that was wanted and offered to do it over. Rogers chuckled, wrote "OK" on the back, and said he guessed he'd quit while he was ahead.

It was during this shooting that Will recounted one of his favorite anecdotes to Abbe, who liked it so much that he recorded it. It seems that Rogers had been a weekend guest of President Calvin Coolidge at the White House.

Gilda Gray

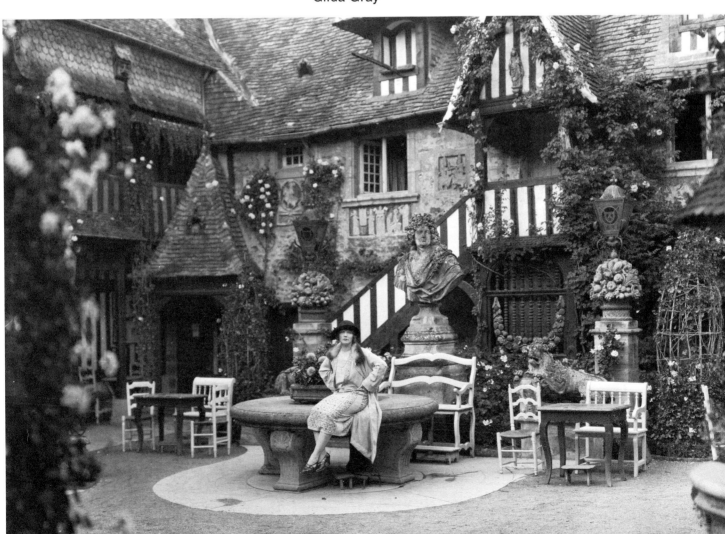

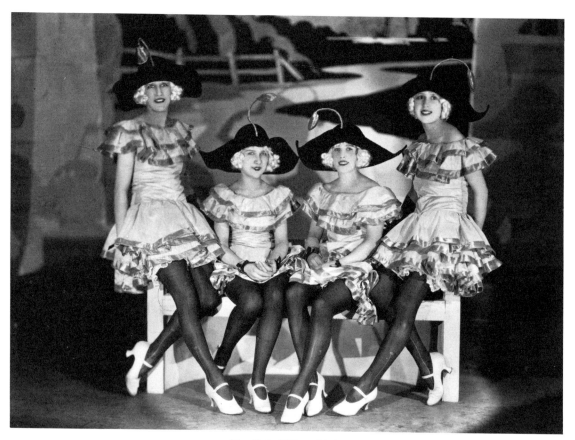

English Tiller Girls

Coolidge had a reputation as a listener comparable to that of Rogers as a talker, raconteur, jokester. Rogers recalled it this way: "It being my first visit to the White House and being invited by the President himself, sleeping in a historic bed, watching my table manners, sitting on the President's right, I figured what was expected of me was to entertain, to talk, tell stories, drag in some famous names of people I'd met since I quit punching cattle to go into show business. I never was one to run out of conversation if the other fella talked back, but Old Cal would just set there and listen. He never laughed once from Saturday suppertime through Monday breakfast. Once or twice he sorta smiled, but along about Sunday noon I got so I couldn't remember which story I'd told. I didn't know what I was supposed to ask the President of the United States. Maybe nothing? Sunday night I took a chance and said, 'Mr. President, how come you seem in such good health, don't look worried or anything, when President Wilson broke down under the strain of being President?' Old Cal thought that one over for maybe two minutes—I figured he was hunting for words of one syllable. Then in his dry voice he said, 'I don't get mixed up with the big problems.' I laughed," continued Rogers, "then wondered if I was supposed to laugh. Cal never changed his expression, and Mrs. Coolidge didn't laugh. But I'd always thought the President of the United States mixed *only* with the big problems. I still don't know how Cal figured it, and I can't even remember what was talked about by me or anybody else for the rest of my visit."

Some years later Abbe repeated Will Rogers' story to Colonel House, President Wilson's "silent partner," to hear his reaction. Colonel House did laugh but followed through with the remark, "That story is not quite as facetious as it sounds. President Coolidge had a talent for choosing subordinates. He hired people to do his thinking for him; asked their advice, then heeded it. President Wilson did the opposite. He was not a good listener, but even when he listened, he seemed to resent advice. He never really liked to delegate authority, although he was, of course, obliged to as President."

Abbe's work was being widely published at this time, and he was much in demand. The *Tatler* of London; *l'Illustration, Vu,* French *Vogue* in Paris; *Berliner Illustrierte Zeitung* and *Die Dame* in Berlin; *Vanity Fair, Vogue, Harper's Bazaar, Metropolitan,* and the *Herald Tribune* in New York, all clamored for his photographs. He was on staff as reporter-photographer for *London* magazine, contributing a feature entitled "Our Tramp Photographer at Large." His pieces ranged from a profile of Mistinguett, or "Miss" as she was known to all of Paris, to a jaunt to Spain, where he photographed the

Parisians enjoying a break between acts at a sidewalk café opposite the Casino de Paris

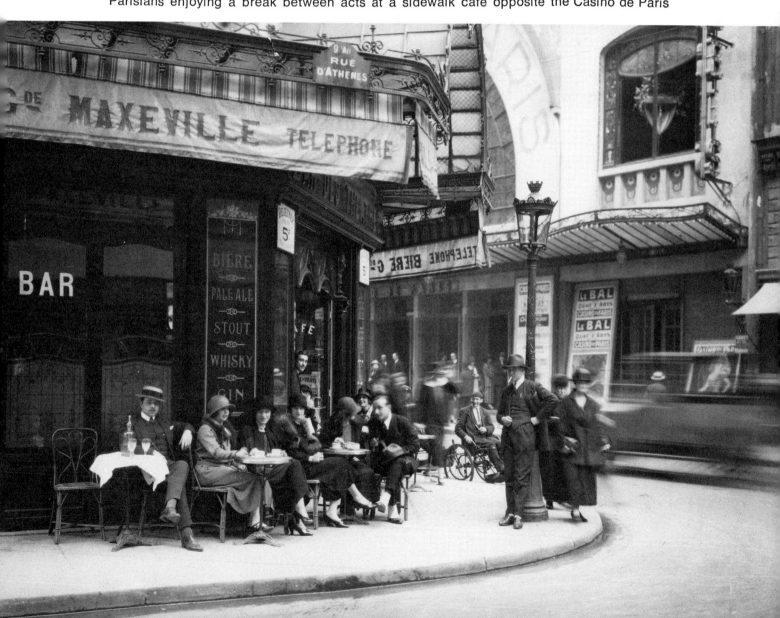

Dora Duby

Cécile Sorel on stage during a performance of the Comédie Française

dancer Petipa and the matador Juan Belmonte (1926), to a motor trip to the South of France, where he was lucky enough to run across the King of Sweden and persuade him to pose for his camera. Always in the right spot at the right time, Abbe reported with his pen with as much wit and sophistication as with his camera. It would not be long before the gaiety of the twenties would give way to the somewhat grimmer reportage he would file from Germany, Mexico, and Russia.

Abbe had always been drawn to the backstage scene as much as to the stars out front, and he was once known to remark, "I have never yet known an actor or actress who was bored with life, and I've known a lot of them. It keeps me on my toes to be mixed up with them. I am not an actor. I am, in a way, an outsider. But I've always seen too much of their life to stay away from it. Anyone who becomes involved in backstage life never gets over it. I've tried and I've failed. I would swap my quiet, peaceful villa for any stage-door man's stall if I thought stage folks were trying to get rid of me. They may not

always be glad to see me, but I've found no other class that can buck me up to such an extent."

Early in his career Abbe met the one star who inspired him more than any other—the incomparable Anna Pavlova. While still in New York he had photographed her at the old Metropolitan Opera House following her opening-night performance, and had again had that honor in London at Covent Garden, in Paris at the Théâtre des Champs Elysées, and in Deauville at the Casino Theatre. It was here that Patience, one of Abbe's three Parisian-born children, saw Pavlova dance. A few years later (1936) the children, Patience and her brothers, Richard and John, wrote a best seller entitled *Around the World in Eleven Years,* describing their childhood with their peripatetic father. In the book Patience tells of her meeting with Pavlova: "When we lived in St. Cloud Pavlova danced at the Théâtre des Champs Elysées. She saw me and liked me. Pavlova was a beautiful lady with beautiful thin legs and eyes that looked as though they had a lamp in them. She spoke to me also at the Théâtre de

Deauville when we were in Normandie, and from that day on I have chosen to be a dancer, because Pavlova was like a flower and her legs danced so beautiful and so like music and she was a great lady, so I am going to be the second Pavlova."

It was in Deauville also that, when Abbe showed up at the stage door to ask Madame to pose after the performance, her husband, Monsieur Dandré, asked him to wait while he inquired. Pavlova agreed. She greeted Abbe as always with hand outstretched to be kissed, and remarked, "I am sure that when I am in heaven Dandré will say, 'Anna, Abbe is below, telling Saint Peter he wants to photograph you.'" "Ah, Madame," Abbe replied, "now I know how I will get into heaven. Saint Peter couldn't resist if you recommended me."

One day in Paris the dancer told him, "I am still Russian. I dream of dancing again in my native land, even though the Russia I knew has gone with

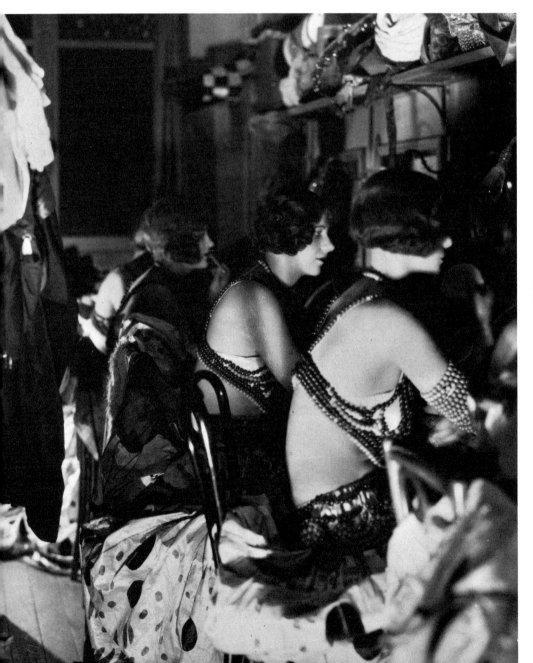

Backstage at the Moulin
Rouge

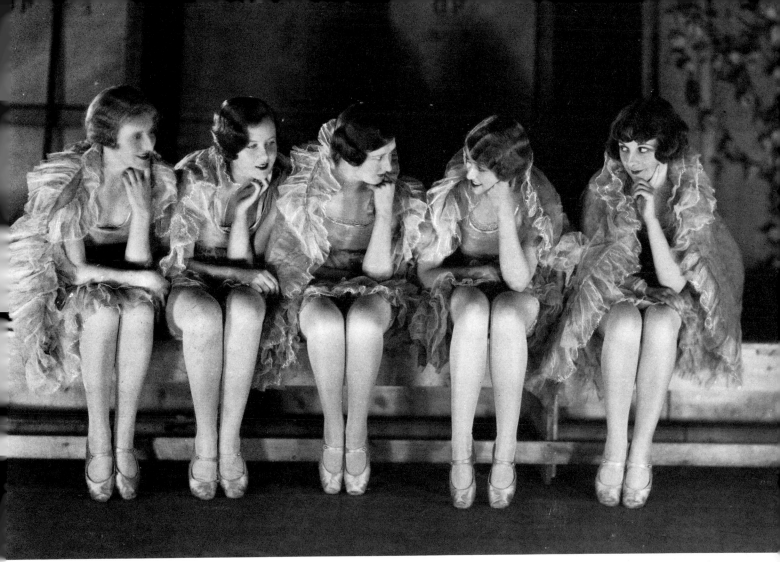

"A hand-picked group of London chorus girls"—as James Abbe recorded on the reverse of the photograph

the revolution." When Abbe visited Russia in 1927, he conveyed her sentiments to Soviet Commissar of Art and Culture Lunarcharski and to the great stage producer Stanislavski. Both declared that Pavlova not only would be welcome but would be permitted to depart without hindrance. Returning to Golders Green near London, where Pavlova lived, Abbe passed on the messages. The reluctant expatriate was deeply moved. With tears in her eyes she listened as Abbe described to her the Russia he had seen. But she never returned.

By the end of the twenties events were taking Abbe's career in another direction. En route to Cuba on assignment for *London* magazine, Abbe heard the news that a revolution had broken out in Mexico. He remained in Havana long enough to file stories for the magazine and a front-page article for the *Herald Tribune* in New York. He then boarded a plane for Mexico and arrived at the front in time to cover the last three days of fighting.

Enchanted by the country, especially in peacetime, Abbe decided he had found his spiritual home. He photographed the outdoor art schools, persuaded artist Diego Rivera to pose for him, and covered the dance and theater at the Mexico Theatre Regis. "Never have I been quite so settled down in a country,"

he wrote. "I've found out where I belong at last." He cabled his wife in Normandy to bring "those annoying but adorable children" to join him, but before they arrived he was recalled to Paris to cover the "Big Five" (Lanvin, Worth, Lelong, Boulanger, and Molyneux) of the fashion world.

By now Abbe was moving away from the theater and screen world. He began concentrating seriously on his writing. As many of his assignments still involved photography, Abbe trained his son, James Abbe, Jr., who came to live with him for a year, to be his photographic assistant. The younger Abbe, a lad of eighteen at the time, recently reminisced about that experience (late 1929 to early 1931). "I recall being fascinated by my father's world. Naturally, at that age, the whole scene left a lasting impression on me. Papa only did what interested him—but once his enthusiasm was aroused, there was no holding him. He lived his whole life that way—always enjoying whatever he was doing."

Father again had son accompany him after his return to the States when he went on an assignment to Harvard in 1935, and again when Abbe, Sr., was granted an interview with F.D.R. in Washington.

As the thirties began, Abbe was still based in Paris, roaming wherever assignments took him. He filed stories on Montparnasse and Juan-les-Pins for *London* magazine. A lengthy photo essay from England on Oxford University was reproduced throughout the world. In 1932 he was off on another trip to Russia, where he became the first foreign correspondent to photograph Stalin. It took weeks of maneuvering, but finally Abbe was summoned to the Kremlin. Stalin had granted him five minutes but wound up giving him thirty. Knowing that Stalin was notoriously shy, Abbe decided to use an ordinary folding Kodak, on the theory that it would be less scary than any of the complicated German cameras he normally used. The sitting was a tremendous success, and the resulting photographs were widely published, as were Abbe's photo essays on Russian theater and ballet.

The following year Abbe found himself on assignment in Germany, working for the *Times* of London. Once again he scooped his colleagues by being the first to publish photographs of Hitler with President von Hindenburg at a parade in Potsdam—a prelude to the military displays that were to become so familiar in that decade. In Berlin he interviewed and photographed Göring and Goebbels and covered the Heidelberg dueling club. Still occasionally drawn back to the theater, he photographed Elisabeth Bergner and Emil Jannings. He missed Marlene Dietrich, who had already left for Hollywood, and never caught up with her. She and Garbo were the two big misses of his career.

Everything that Abbe saw in Berlin convinced him that it was time to take his family back to America. They returned to the United States in 1934. He settled on a ranch in Larkspur, Colorado, until 1936, when he once more took off as photographer-correspondent for the North American Newspaper Alliance, covering the Spanish Civil War from the Franco side. Ernest Hemingway was his opposite number on the Loyalist side of the lines.

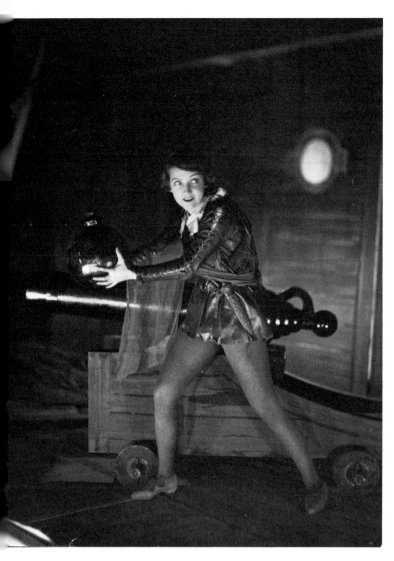

Dorothy Dickson as Peter Pan

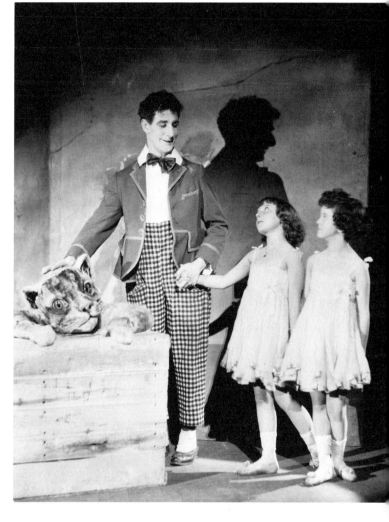

Fred Stone and charming audience

After the publication and success of the book *Around the World in Eleven Years,* Abbe's wife Polly and the three children decided to return to Germany to write a book about the Nazi movement. Abbe, who thought the plan ill-conceived, remained in Larkspur, where he began writing a weekly column for the local newspaper. For many reasons Abbe and Polly decided to make the separation permanent.

In the late thirties Abbe began a new career and a new family in Sheridan, Wyoming. As a radio news commentator he traveled with his wife, Irene, and daughters to Portland, Oregon, and eventually to San Francisco to cover the

Diego Rivera

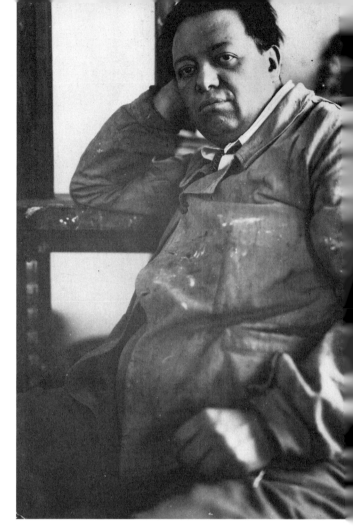

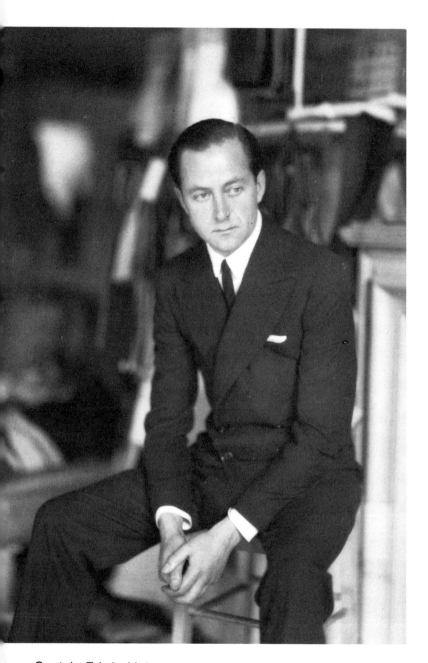

Captain Edwin Molyneux

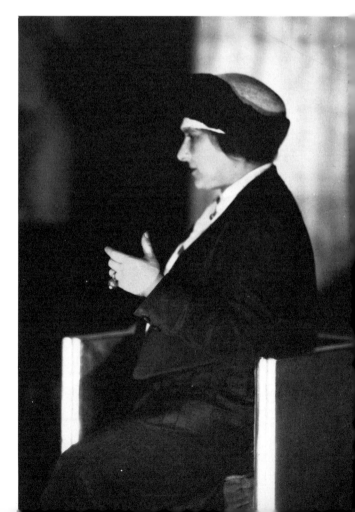

Helena Rubinstein

Jean Lanvin

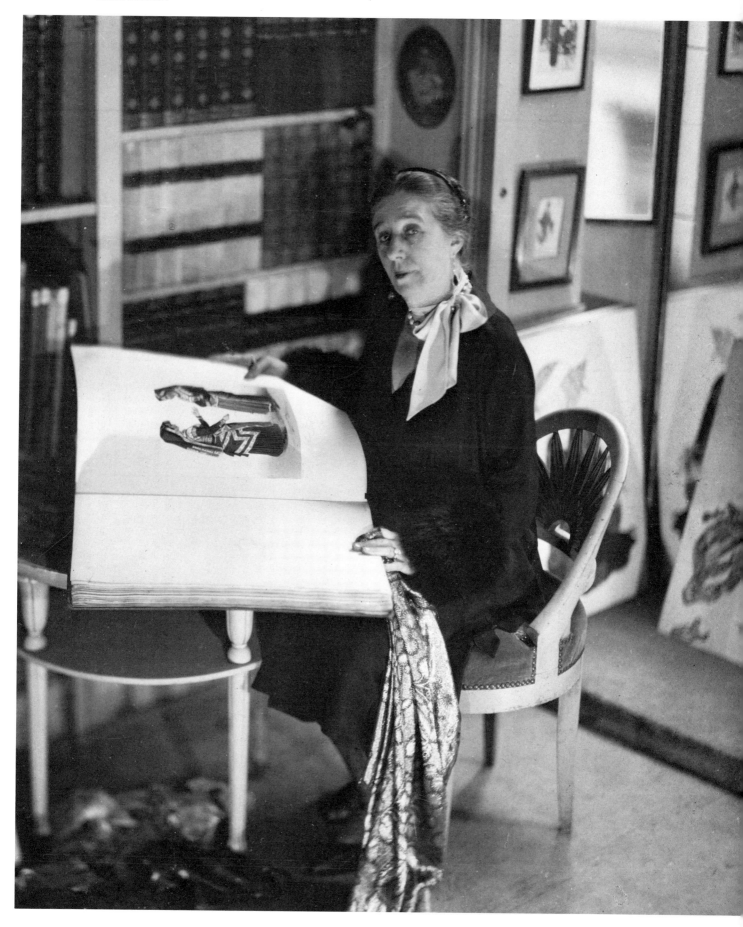

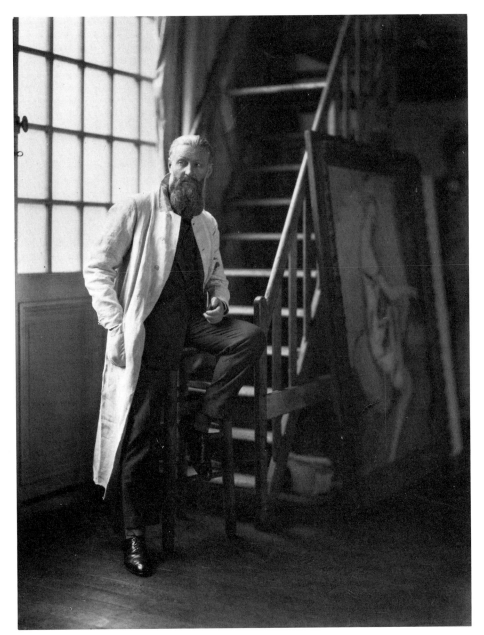

Kees van Dongen

birth of the United Nations in 1945. Instead of reporting World War II on location as he had other wars, he did so through his nationwide radio program "James Abbe Observes." When the world discovered television in the early fifties, Abbe again opened a new door and became a television critic for the Oakland *Tribune,* until his retirement in 1961.

Abbe had finally settled down, and he now "lived happily ever after," as he liked to say, with his wife, and daughters Melinda (Linda) and Matilda (Tilly). Talking about her father recently, Tilly stated:

> Papa may have ceased his wanderings, but he never lost his intense interest in people and the world. In fact, his last thirty-five years, those spent with my mother, my sister, and me, couldn't have been more active or vibrant. At age seventy-five he was pictured in

Sports Illustrated magazine mid-air in a backflip off a swimming-pool springboard.

Of the many accomplishments in his lifetime none brought him more pleasure than his eight children, eighteen grandchildren, and five great-grandchildren. He proudly took credit for all!—and then some. For he was affectionately "Papa" to all who knew him.

As I was dancing my way around the far corners of the world with the San Francisco Ballet Company, there was always a letter waiting at every stop. It would begin "Dear Dancing Daughter, Tilly and Co. . . ." and the entire troupe would gather 'round for a reading of Papa Abbe's latest.

Joseph Stalin

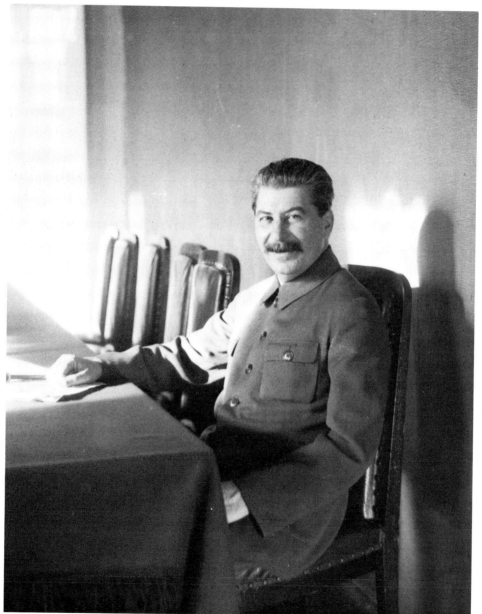

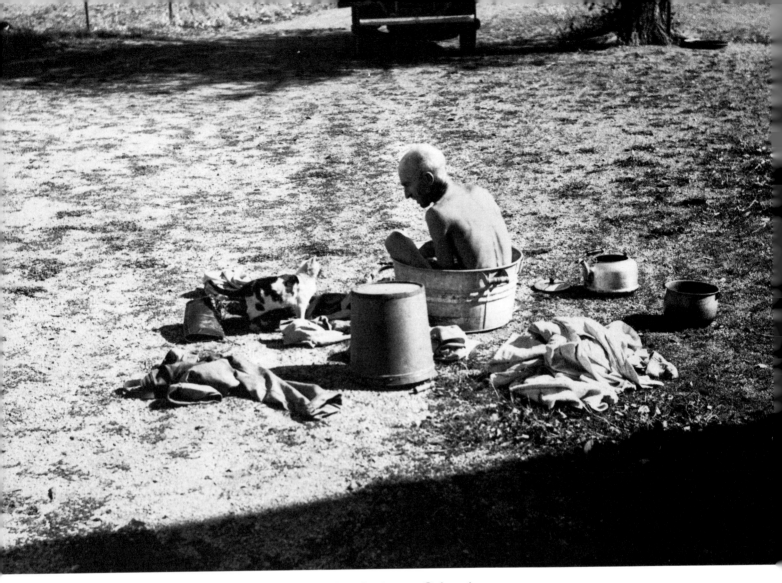

Near Larkspur, Colorado

In mid-October 1973 (a month before his death), Papa was sitting on the edge of his bed, his luminescent blue eyes reflecting the light of the sunny sky outside. He said to me, "I wouldn't mind dying if only I knew I wouldn't have to miss anything."

He had an eye for a photo, a nose for a story, and a way with people. Add a terrific sense of humor and you have the magic combination that guided him through the years of his long, adventurous life.

The Portraits

Descriptions of the 105 portraits in the order of their
appearance from page 33 to the end of the book

1. FAY COMPTON as Ophelia (played opposite John Barrymore's Hamlet) delighted London's theater-goers in 1925.
2. RUTH CHATTERTON in the Broadway production of *La Tendresse,* 1922.
3. ESTELLE WINWOOD in 1921, the year of her celebrated performance in W. Somerset Maugham's comedy *The Circle* at New York's Selwyn Theatre.
4. JANE COWL in *Smilin' Through,* 1920. Abbe was sent to Detroit to photograph the entire cast before the play came to Broadway—and success.
5. YVONNE PRINTEMPS, Paris, 1926. Besides Yvonne, Abbe also photographed her husband, Sacha Guitry, and father-in-law, Lucien Guitry, many times during the early twenties—years characterized by success, popularity, and Sacha's numerous plays.
6. RICHARD BARTHELMESS and GLADYS HULETTE, stars of the film *Tol'able David,* 1922.
7. PAULINE LORD in the Eugene O'Neill masterpiece *Anna Christie,* Broadway, 1921.
8. ALEXANDER WOOLLCOTT, noted drama critic and author, having a bit of fun, c. 1920.
9. OTIS SKINNER, Cornelia's famous father, at about the time he triumphed in *Blood and Sand* (c. 1921).
10. WALTER HAMPDEN, whom American theater audiences eagerly applauded, especially in his leading roles in several Shakespearean productions and *Cyrano de Bergerac* (performed in 1923 and revived in 1924 and 1926).
11. BLANCHE YURKA. Her moving Gertrude in *Hamlet* illuminated the stage in 1922, as did her performances in *The Goat Song* (1926) and *Hedda Gabler* (1929).
12. EVA LE GALLIENNE starring in *Joan of Arc,* Paris, 1925. She was born in London of French parentage and brought up in America, and the French resented this portrayal of their heroine by a foreigner. The Paris critics were hard on both the actress and the play.
13. The original vamp—THEDA BARA, c. 1920.
14. MAE MURRAY, who treated movie fans to *On With the Dance, The Right to Love,* and *Idols of Clay* in 1920.
15. Humor, verve, and boundless vitality—that was JOSEPHINE BAKER capturing Paris in 1927.
16. The famous Swiss clown, GROCK, in *Rue de la Paix,* Paris, 1926.
17–19. CHARLIE CHAPLIN in Paris, 1922, plus two poses of him as *The Tramp,* 1927. Chaplin was an extremely reluctant subject for Abbe's camera. Ever since they had first met in Hollywood in 1919, Abbe had tried to photograph the great Chaplin; it was not until he shot the stills of *The Pilgrim,* starring Chaplin and Jackie Coogan, that he succeeded.
20. CECIL B. DE MILLE, who created many of the greatest stars the film world was to know.
21. LILLIAN GISH and RONALD COLMAN in the 1922 movie *The White Sister.*
22. RUTH GORDON, c. 1921, as she appeared in Booth Tarkington's play *Seventeen,* one of the first teen-ager plays to be offered a sophisticated New York audience.
23. POLA NEGRI, c. 1927, photographed in Abbe's Paris studio. Pleased with the photographs Abbe had taken of her in New York, she looked him up in Paris while on her way to her native Poland and again posed for him.
24. MARION DAVIES in Abbe's New York studio, c. 1920. Recently picked from the chorus line of the *Ziegfeld Follies,* Davies was starring in a nightclub revue at The New Amsterdam Roof. Her famous romance with William Randolph Hearst had just begun.
25. HEDDA HOPPER, c. 1922, playing in *Six Cylinder Love* in New York and recently married to DeWolf Hopper. She later became famous for her hats and her Hollywood gossip column.
26–27. JEANNE EAGELS, after she became the toast of Broadway in *Rain,* c. 1920.
28. BETTY COMPSON, photographed three years after her overwhelming success in *The Miracle Man,* c. 1921.

29. Former vaudevillian INA CLAIRE, the year she portrayed Monna in *Bluebeard's Eighth Wife* (1921).

30–31. GLORIA SWANSON, c. 1921. Abbe first met Swanson in New York in 1921; he followed up the acquaintance in Paris in 1927. They loved to exchange sentimental memories of when they had worked for Mack Sennett in Hollywood.

32–33. ANNA PAVLOVA, 1927 and 1928, the great Russian ballerina with whom Abbe shared a long and close friendship. He often declared that she was his greatest inspiration.

34. As talented as her well-known brother Nijinsky, NIJINSKA appeared at the Ballets Russes in 1927, where Abbe photographed her.

35. LUBOV TCHERNICHEVA, of the Ballets Russes, 1927.

36. TILLY LOSCH, premier danseuse of the Vienna National Opera and an instant success when she appeared in Paris, c. 1925.

37. The famous Spanish dancer, ARGENTINA, as she appeared in New York, c. 1928.

38. FOKINE and FOKINA, husband-and-wife refugees from the world-renowned Imperial Ballet, Russia, in their New York dance studio, 1920.

39. LUCETTE BAUDIER, Paris Opéra dancer, c. 1928.

40–45. One of the theater's acclaimed couples: GERTRUDE LAWRENCE and NOËL COWARD, backstage and on stage in *London Calling,* 1923.

46. CICELY COURTNEIDGE with her brother CHARLES, at the Gaiety Theatre, New York, stars of her husband Jack Hulbert's revue *By-the-Way,* 1926.

47. LESLIE HOWARD, fresh from the London stage, and ALEXANDRA CARLISLE in *The Truth About Blayds,* Broadway, 1922.

48–51. The famous brother-and-sister dance team, FRED and ADELE ASTAIRE, in the musical *The Love Letter,* Broadway, 1921, and in a studio portrait, 1926.

52–55. BEATRICE LILLIE, English comedienne, as the young curate in Noël Coward's *London Calling,* 1923, and as a cockney maid.

56. KATHARINE CORNELL, c. 1920, photographed at the request of Guthrie McClintric, who later married her and guided her acting career.

57. IRVING BERLIN, flanked by two show girls, at the opening of the Music Box Theatre, New York, 1921.

58. CAROLE LOMBARD while still a Mack Sennett bathing beauty, 1921.

59. HENRY HULL and FLORENCE ELDRIDGE in *The Cat and the Canary,* Broadway, 1922.

60. LIONEL BARRYMORE and IRENE FENWICK in the 1921 Broadway production of *The Claw.*

61–63. JOHN BARRYMORE in three poses during rehearsal for the London production of *Hamlet,* 1925.

64. Italian opera star AMELITA GALLI-CURCI, after her Metropolitan debut, 1920.

65. FEODOR CHALIAPIN, Russian operatic basso, Paris, 1928.

66. Husband-and-wife film stars DOUGLAS FAIRBANKS and MARY PICKFORD at Aix-les-Bains, France, 1925.

67. MARY PICKFORD, during the filming of *Suds* in Hollywood, 1920.

68. FANNY BRICE, at the start of her busy twenties career on the Broadway stage (1921). Abbe found her a natural comedienne, equally funny offstage as on.

69. BILLIE BURKE, c. 1920, when she was the wife of Florenz Ziegfeld.

70. PEARL WHITE in her home in Paris, 1923. After making a fortune in movies, she no longer worked on the stage or screen. Some of her time was devoted to posing for advertisements; most of it was spent living luxuriously.

71. BEBE DANIELS, star of stage and screen, photographed in London, 1925.

72. MAE WEST, 1920, when Broadway applauded her in *Diamond Lil.*

73. TALLULAH BANKHEAD, 1925, when she starred in *Conchita* on the London stage. Backstage, Tallulah held court with as much success as the popular Astaires.

74. EDWARD G. ROBINSON (third from left) and friends in the play *The Deluge,* 1922.

75. ED WYNN, after he opened in *The Perfect Fool* on Broadway (c. 1921). Abbe

claimed that of all the comedians he photographed, Wynn stood head and shoulders above the others.

76. Seven months after her first appearance on stage in *Inheritors,* ANN HARDING inspired rave reviews for her performance in *Like a King,* New York, 1921.

77. RUDOLPH VALENTINO, 1922.

78. RUDOLPH and NATASHA VALENTINO, 1921, posed in Abbe's New York studio. It was Abbe's idea to position the Valentinos in profile, suggesting that their joint popularity at that time was so immense that one might imagine them appearing on a silver dollar. Previously, Valentino, an Italian immigrant gardener before Hollywood fame, had been married to Jean Acker. Natasha Rambova, Russian-born, and adopted daughter of millionaire Richard Hudnut, had made quite a name for herself as a ballerina prior to meeting Valentino.

79. WILL ROGERS, 1927. After creating a stir in the *Ziegfeld Follies* and *Night Frolics,* this satirical homespun entertainer went on to achieve further success in the movies and as an author.

80. NELSON KEYS, DOROTHY GISH, and WILL ROGERS researching show business, 1927.

81. One of the great comedians—HAROLD LLOYD, c. 1925.

82. Comedy team LAUREL and HARDY with three of Abbe's children: Patience, Richard, and John, 1928.

83. JACKIE COOGAN, "The Kid," Charlie Chaplin's celebrated prodigy.

84. MAURICE CHEVALIER, Paris, 1925, on stage after performing in a frothy song-and-dance show in one of the smaller theaters in Paris. Famous in France, Chevalier was about to try his luck in the States, but was nervous about his French accent!

85. MISTINGUETT, 1927, of Moulin Rouge, Folies-Bergère, and Casino de Paris fame, frequent dancing partner of Maurice Chevalier. Her 1928 show *Le Salon de la Dubarry* prompted great attention and was subsequently banned by the French Government.

86–88. THE DOLLY SISTERS, Rosie and Jenny, in three poses, Paris, 1927.

89. The dynamic AL JOLSON, 1926. His 1927 performance in *The Jazz Singer,* the first big "talkie," marked the movie industry's emergence into a new era.

90. GEORGE GERSHWIN, JAMES MELTON, and an unobtrusive fan in the shadows, following a Gershwin concert, 1929, in Washington, D.C.

91. Flapper CLARA BOW, 1922, photographed one year before her first movie, *Bound Down to the Sea in Ships,* was to launch her career.

92. COLLEEN MOORE, star of *Little Orphan Annie, Irene, Smiling Irish Eyes,* and *Footlights and Fools,* c. 1922.

93. English songwriter, actor, and playwright IVOR NOVELLO, London, 1923.

94. GLADYS COOPER and OWEN NARES in the London performance of *Diplomacy,* 1924.

95. PEGGY WOOD, c. 1921, at about the time she completed her two-year tour in *Buddies.*

96. AGNES AYRES, c. 1923, the year her films *The Heart Raider* and *Don't Call It Love* appeared.

97. BESSIE LOVE, photographed in Abbe's Paris studio in 1928. She had been a major star for the past ten years, making her reputation in ingenue roles. At this sitting, she was modeling Paris fashions when she suggested a break and eased over to the stove. Abbe captured the natural, charming picture she made.

98–99. Second from left in the chorus line, HELEN HAYES, and in a more delicate pose, 1921.

100. GEORGE S. KAUFMAN and MARC CONNELLY, co-authors of the hit *Dulcy,* with the star of the show, LYNN FONTANNE, 1921.

101. LYNN FONTANNE, who married Alfred Lunt in 1922 and co-starred with him in a succession of Broadway hits.

102–104. Three stills from the LILLIAN GISH movie *Broken Blossoms,* 1920.

105. ELISSA LANDI in 1926, the year she filmed *London* with Dorothy Gish.

1 Fay Compton

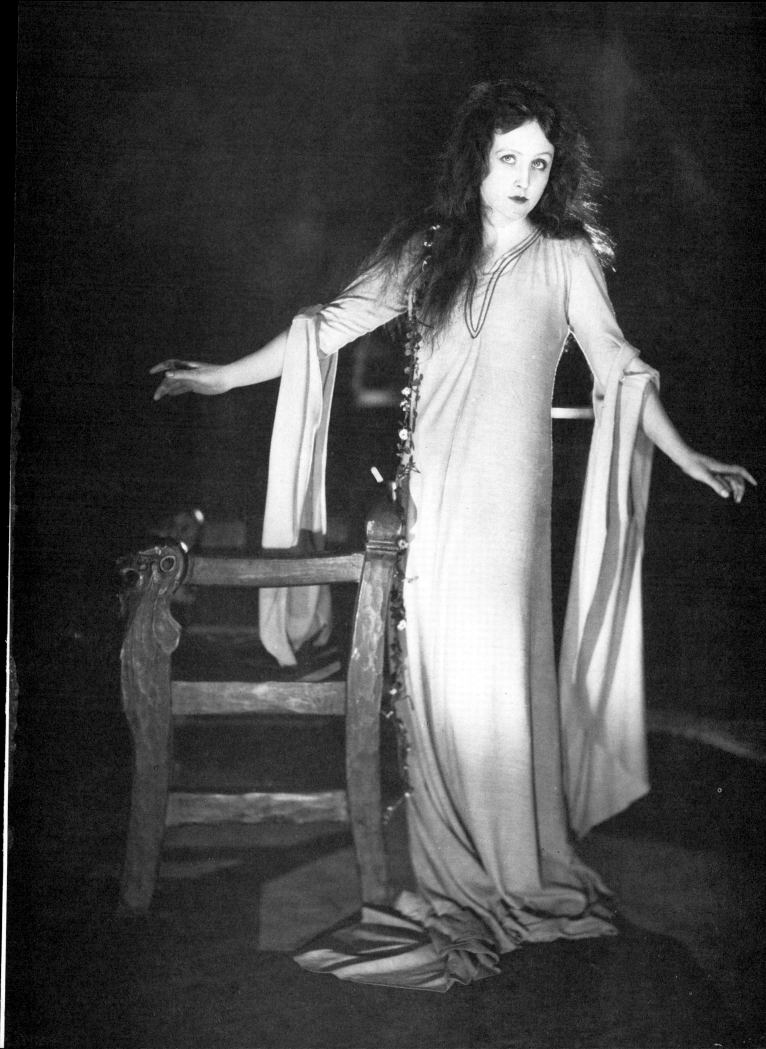

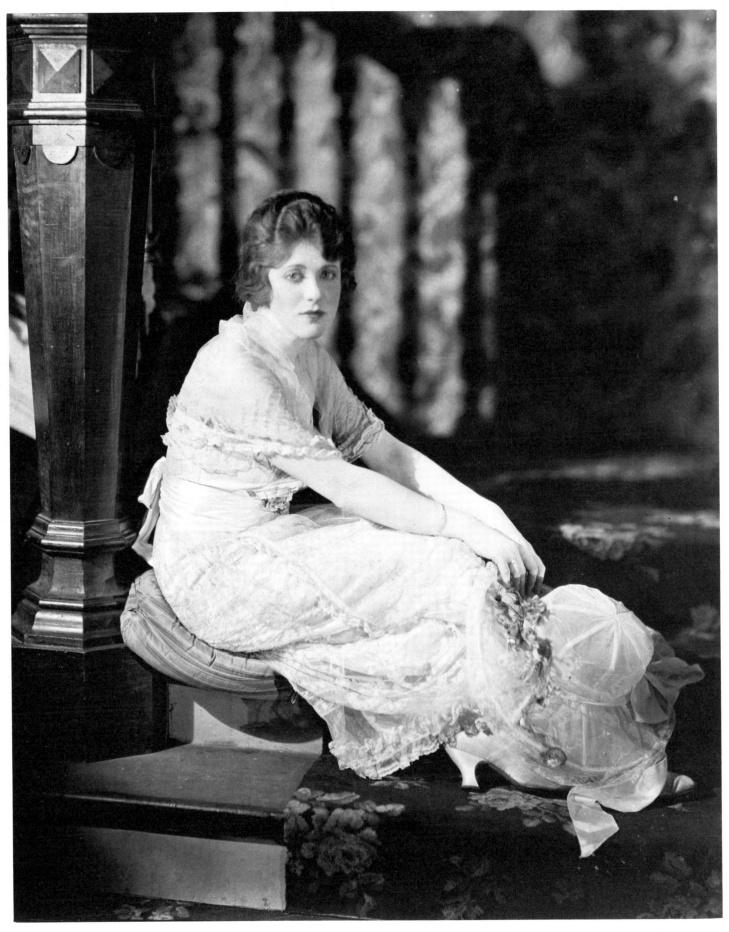

2 Ruth Chatterton

3 Estelle Winwood

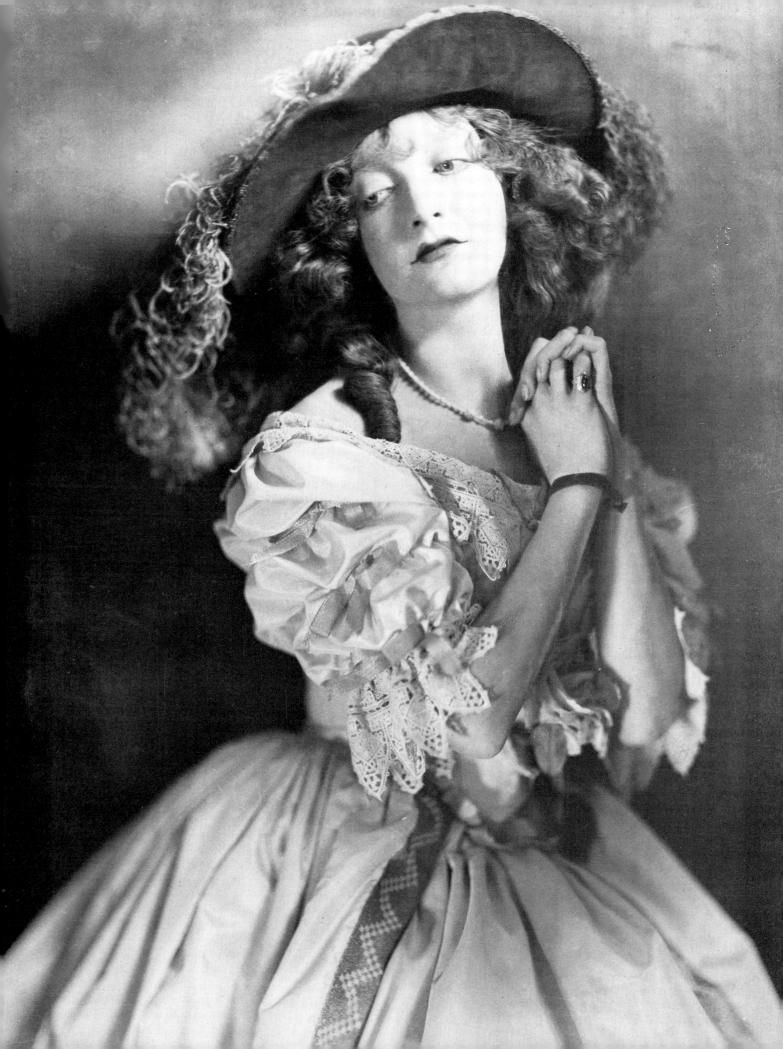

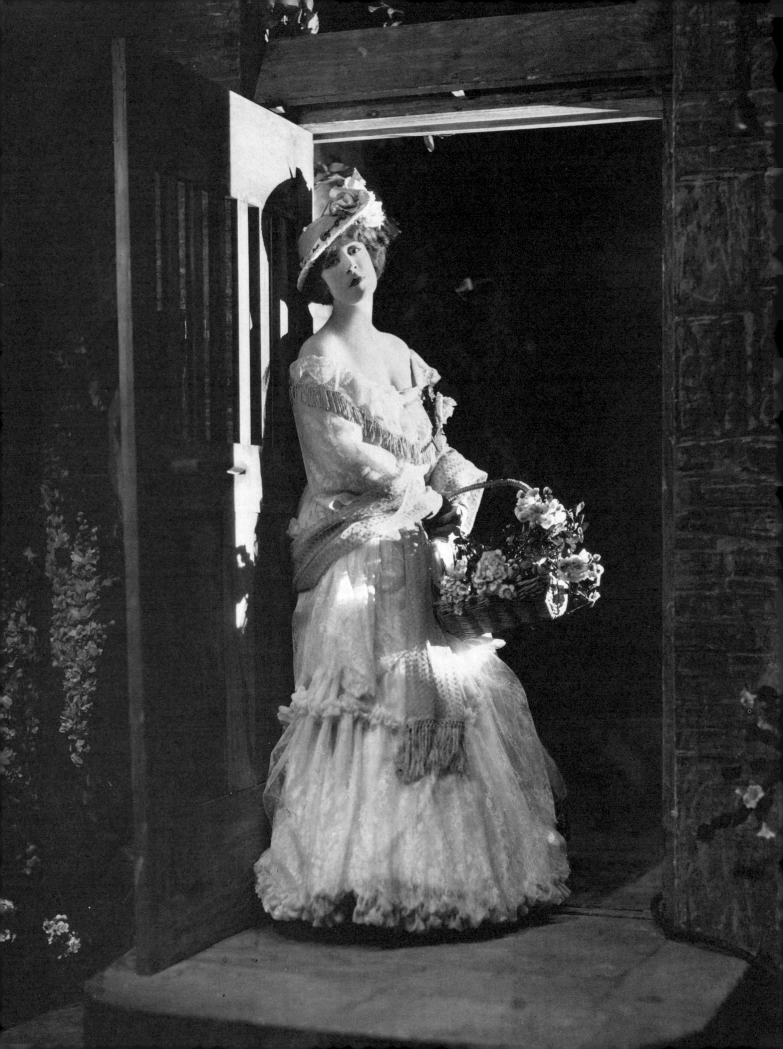

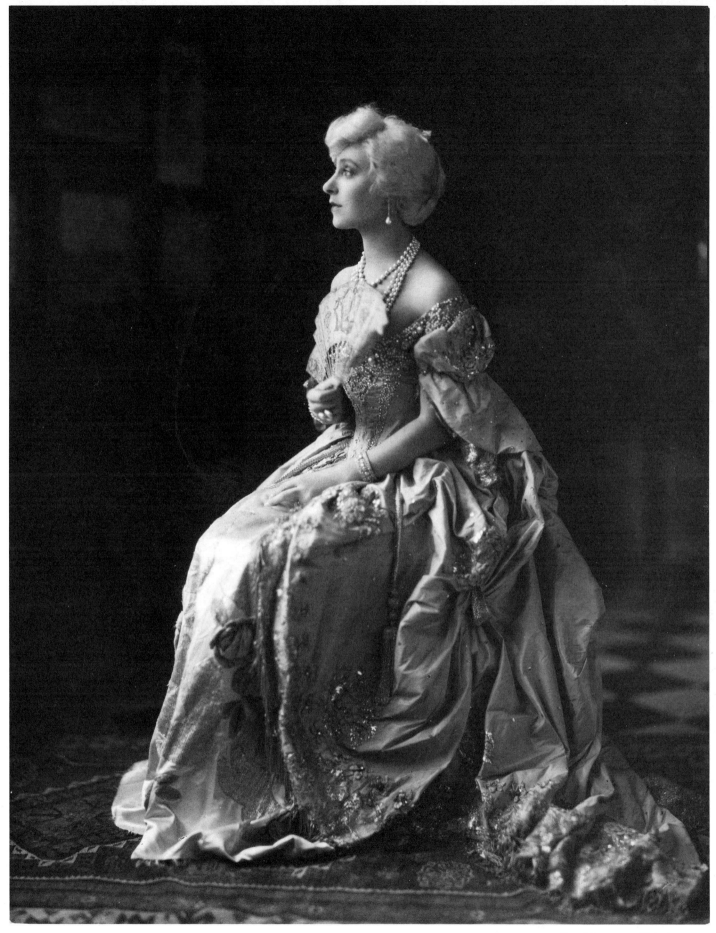

5 Yvonne Printemps

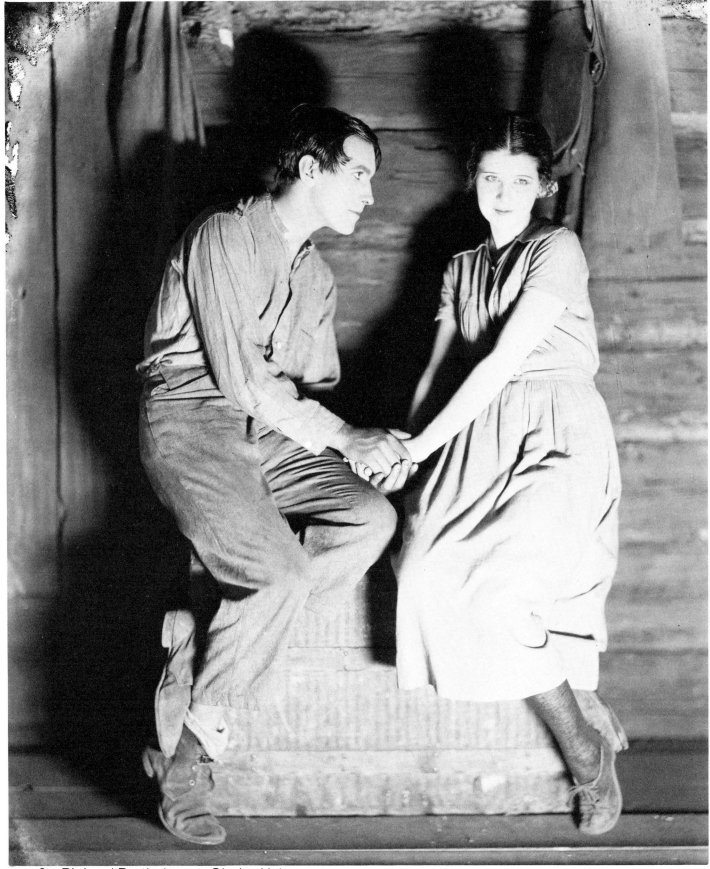

6 Richard Barthelmess, Gladys Hulette

7 Pauline Lord

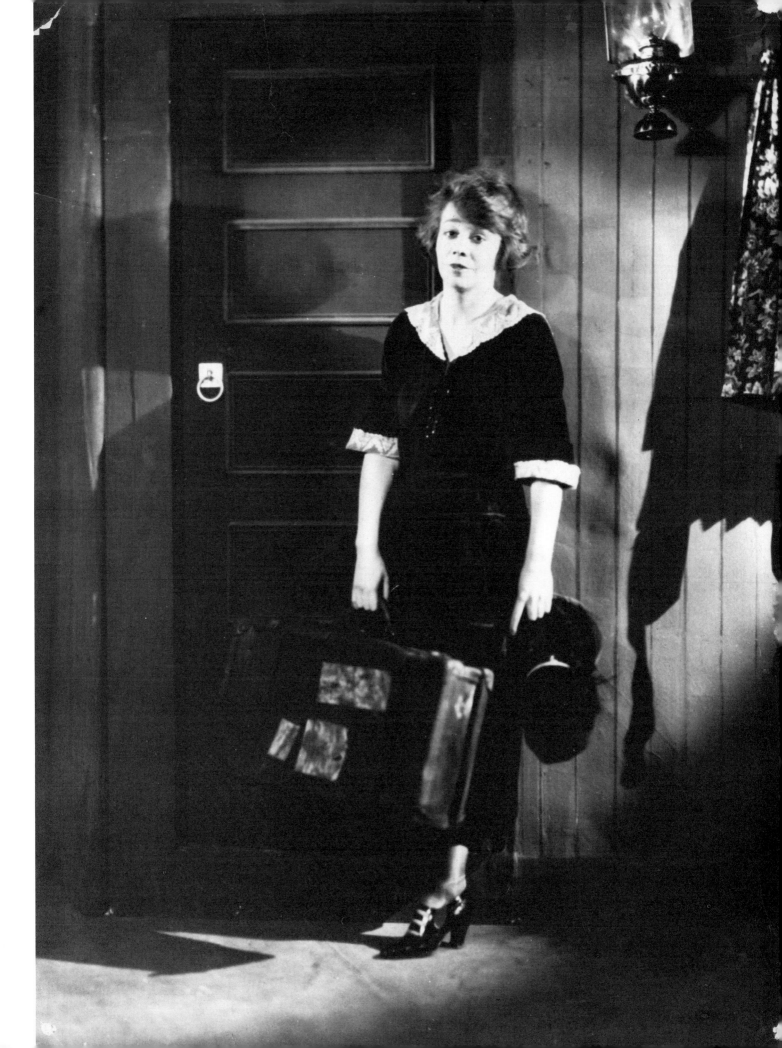

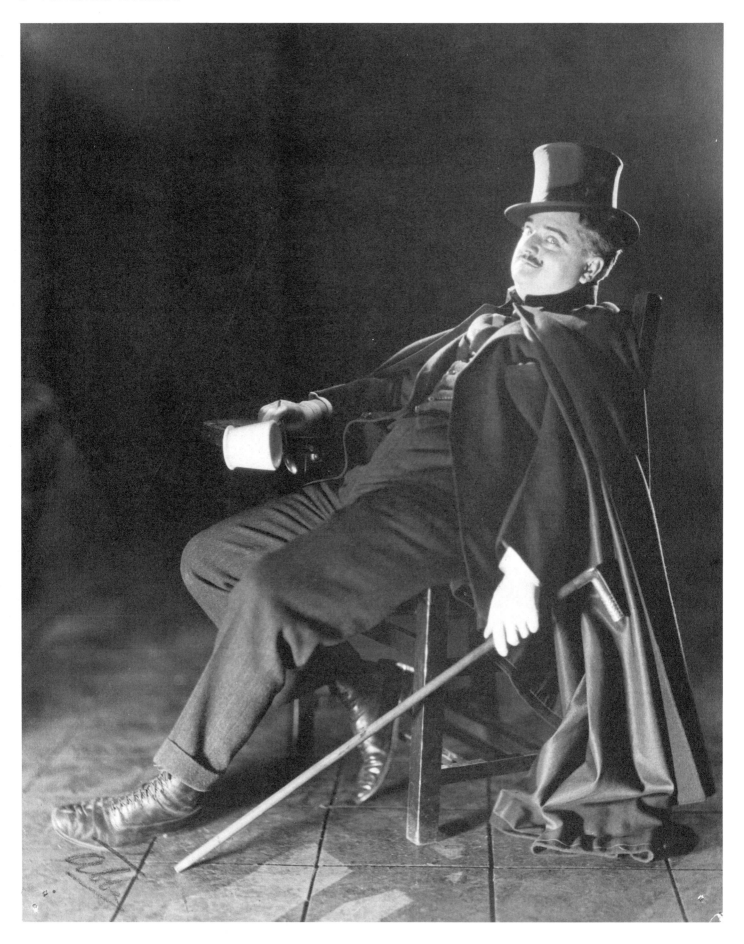

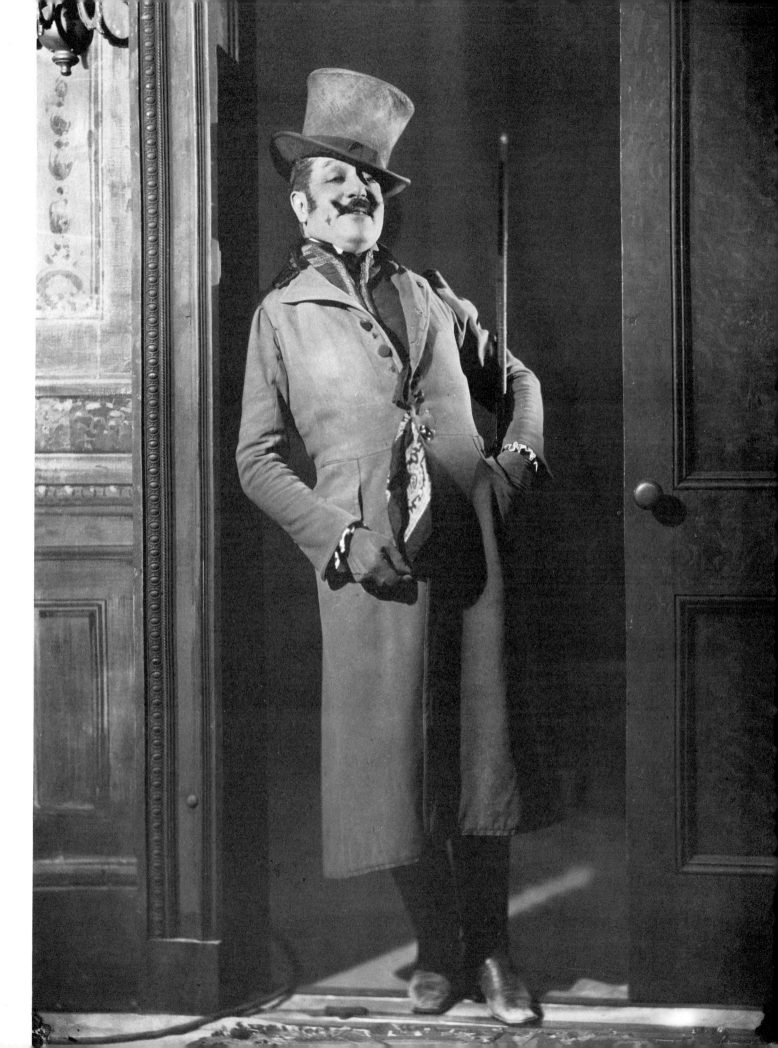

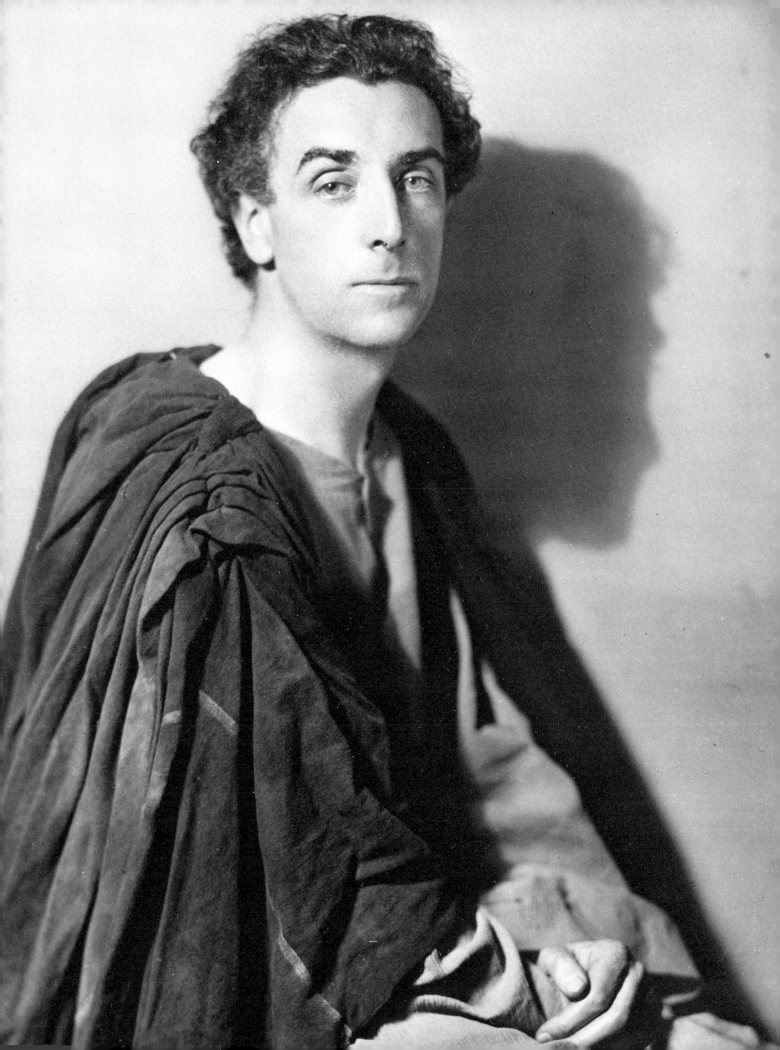

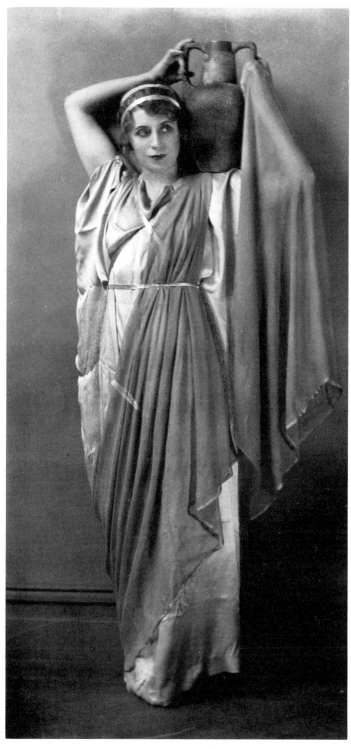

11 Blanche Yurka

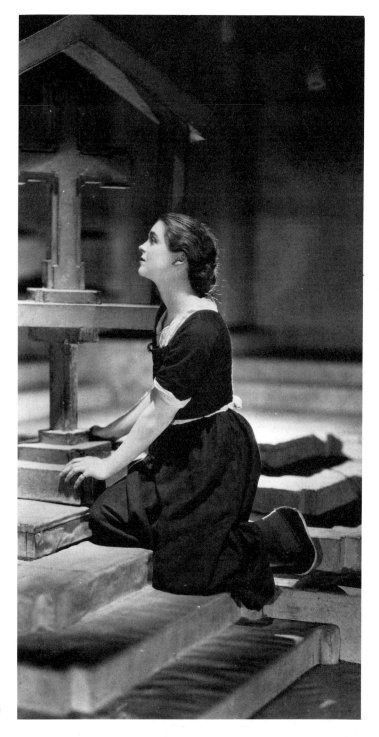

10 Walter Hampden

12 Eva Le Gallienne

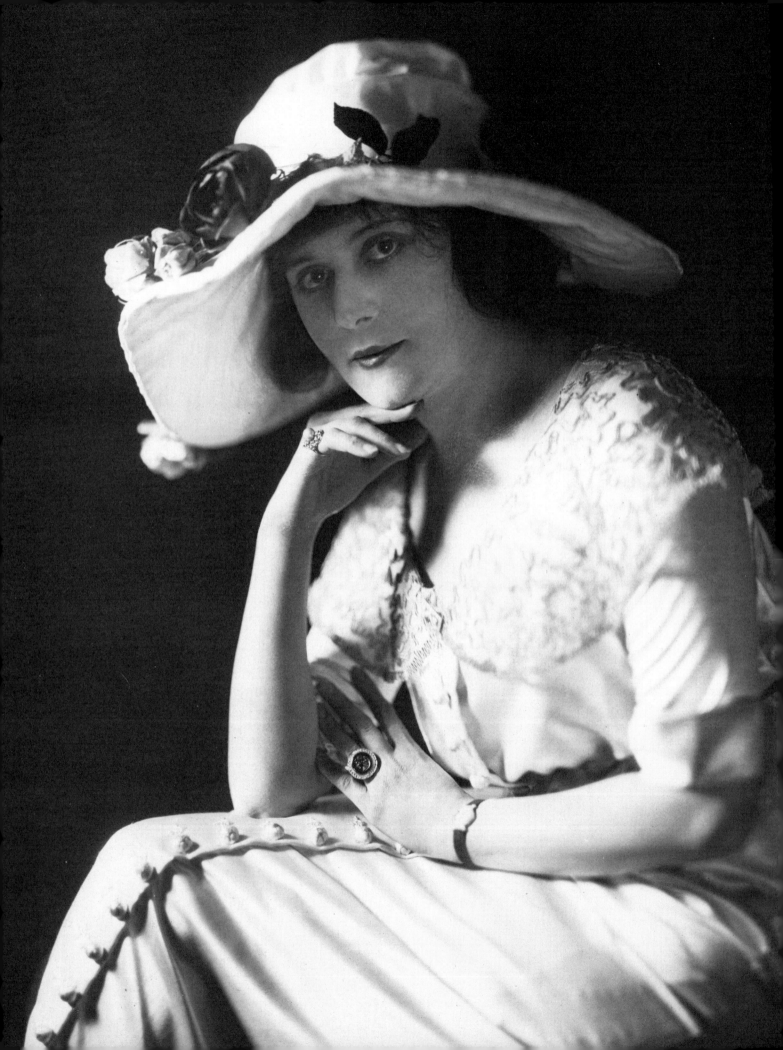

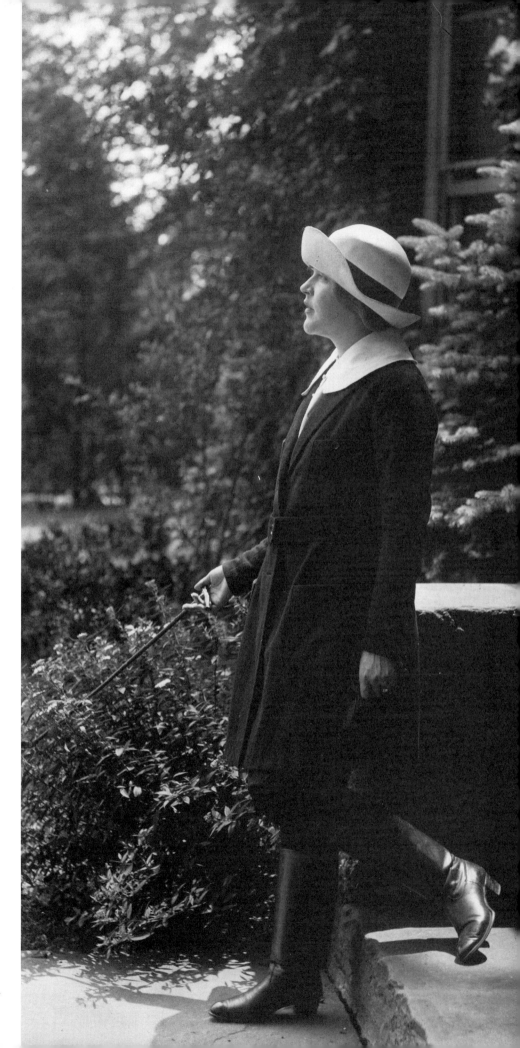

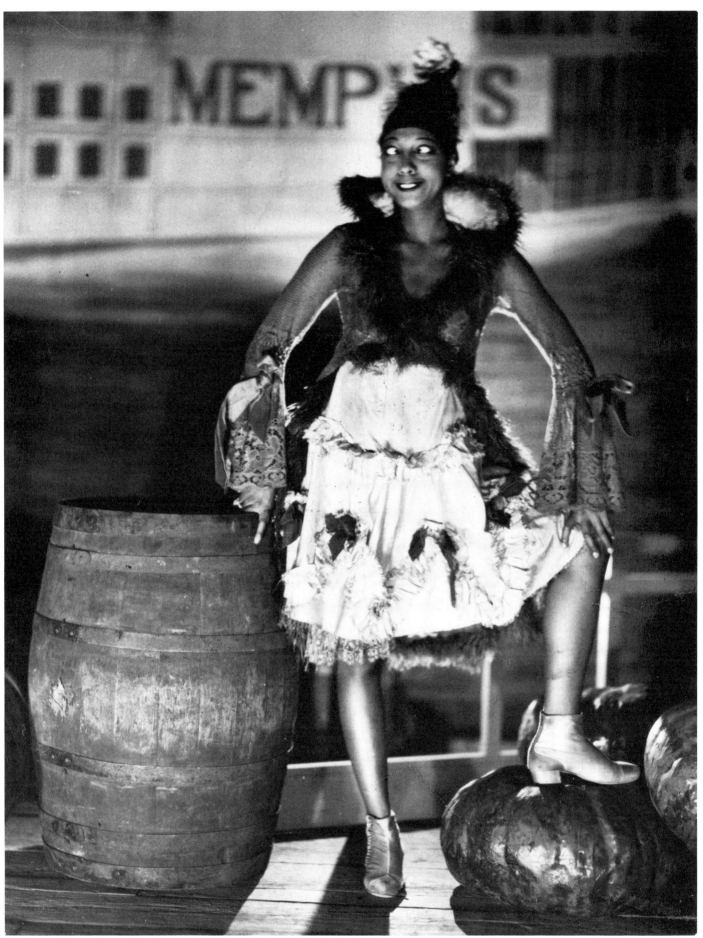

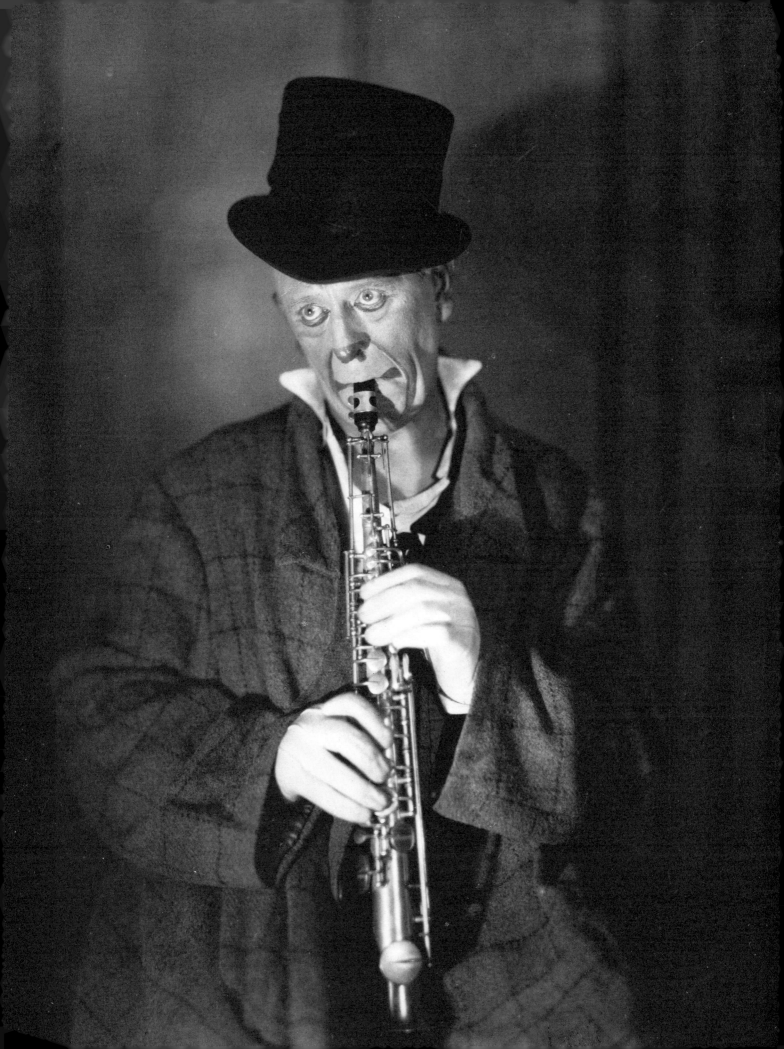

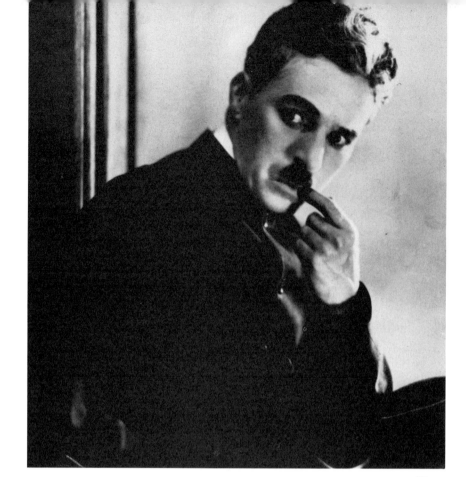

18

Charles Chaplin

17

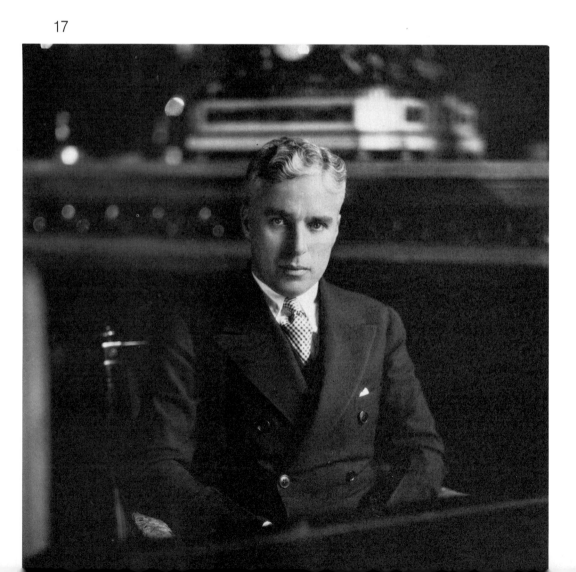

19

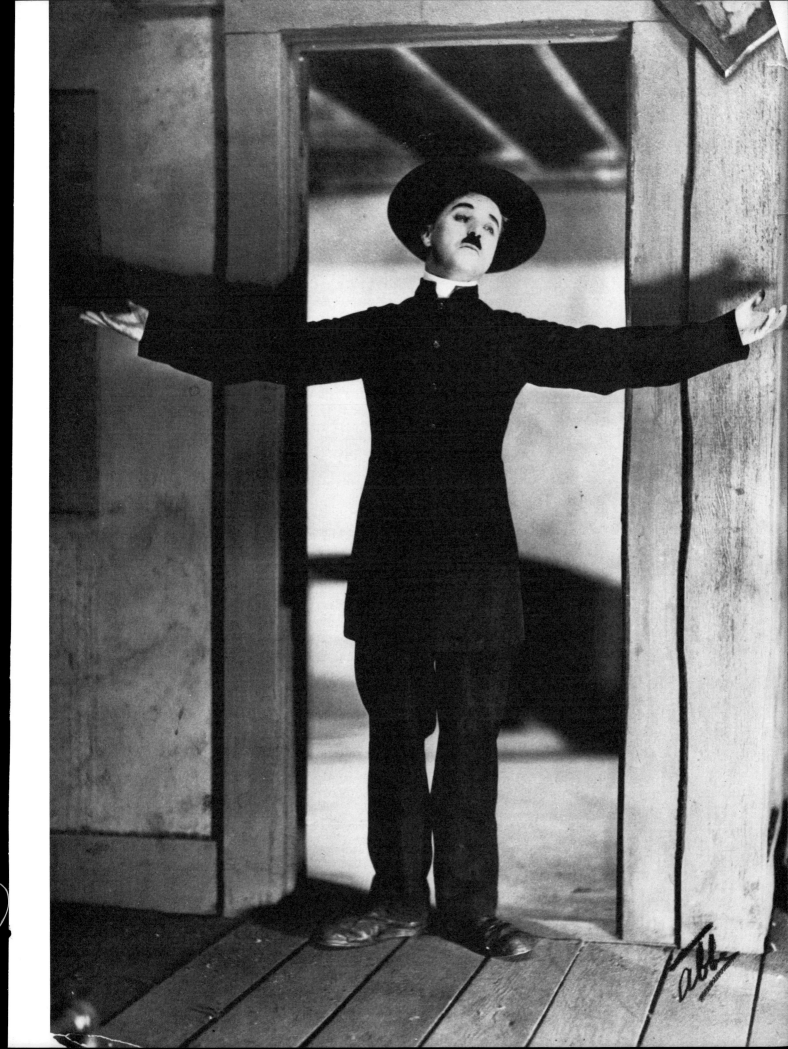

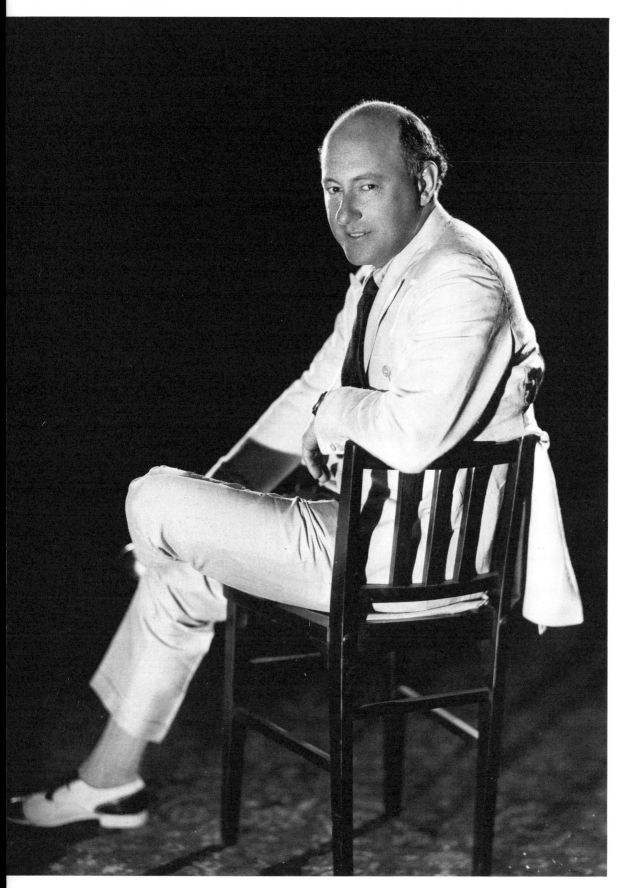

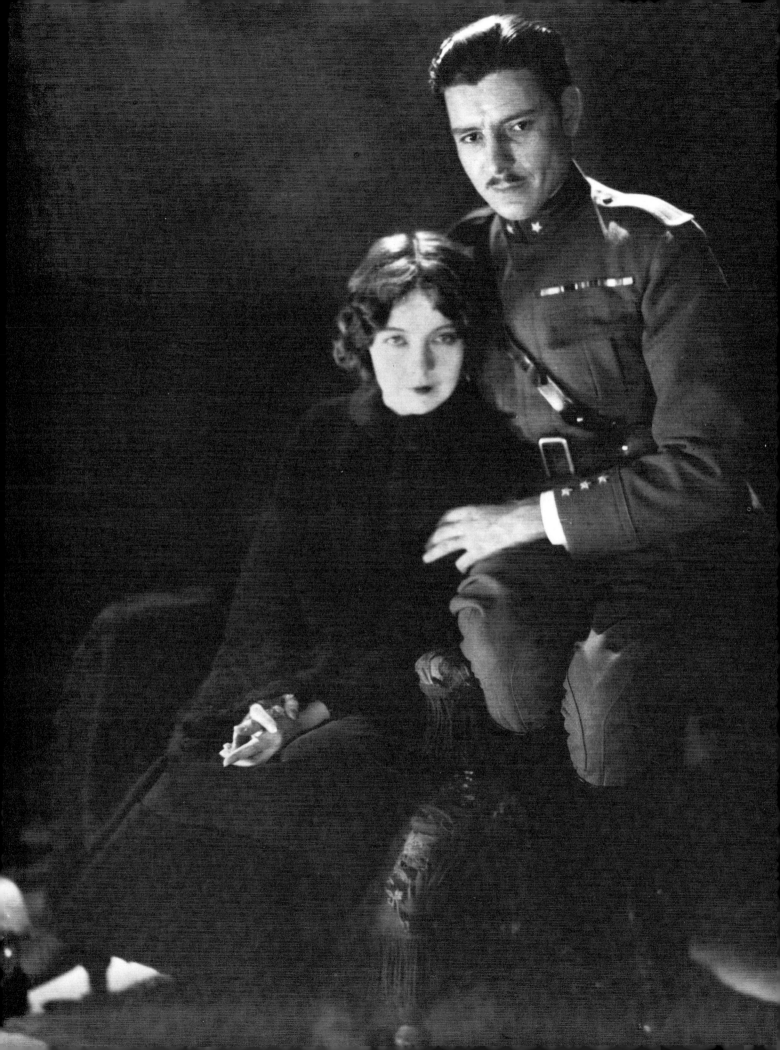

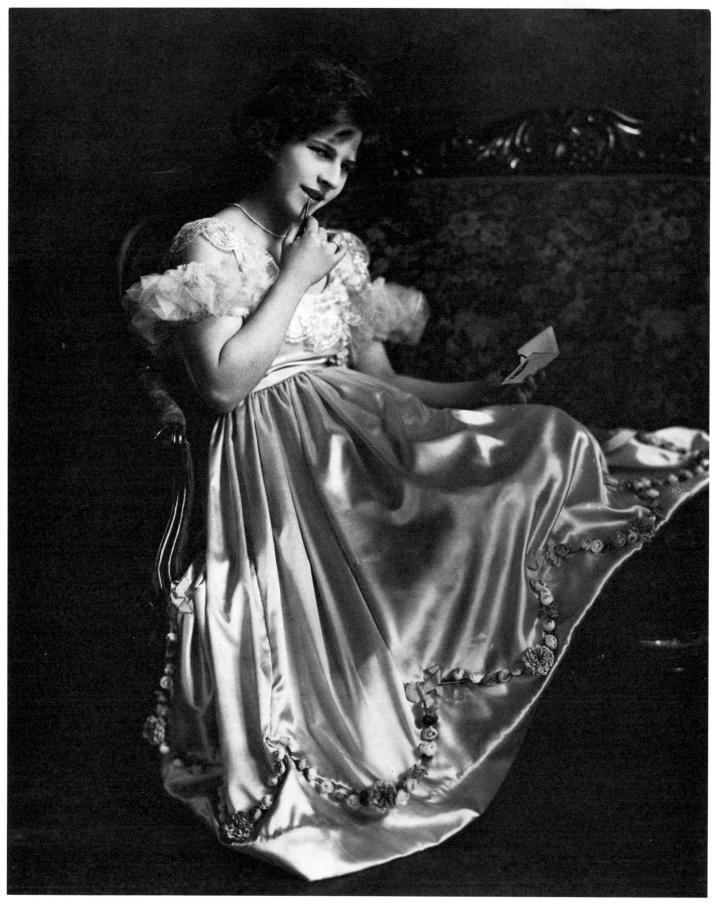

22 Ruth Gordon

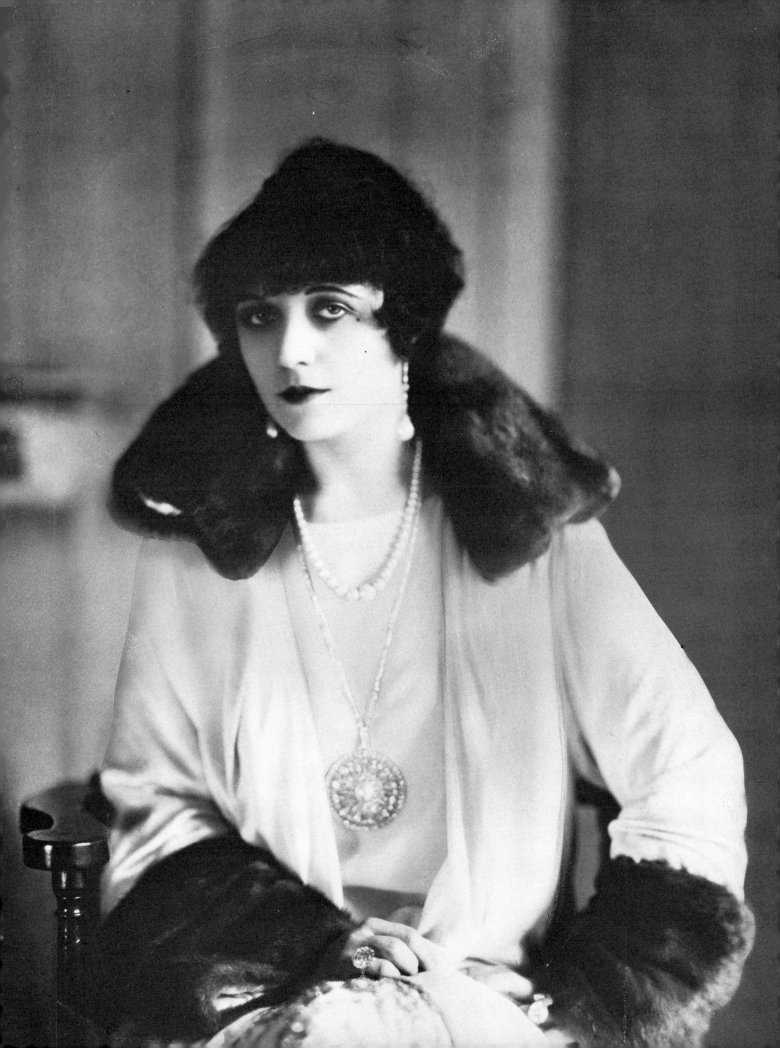

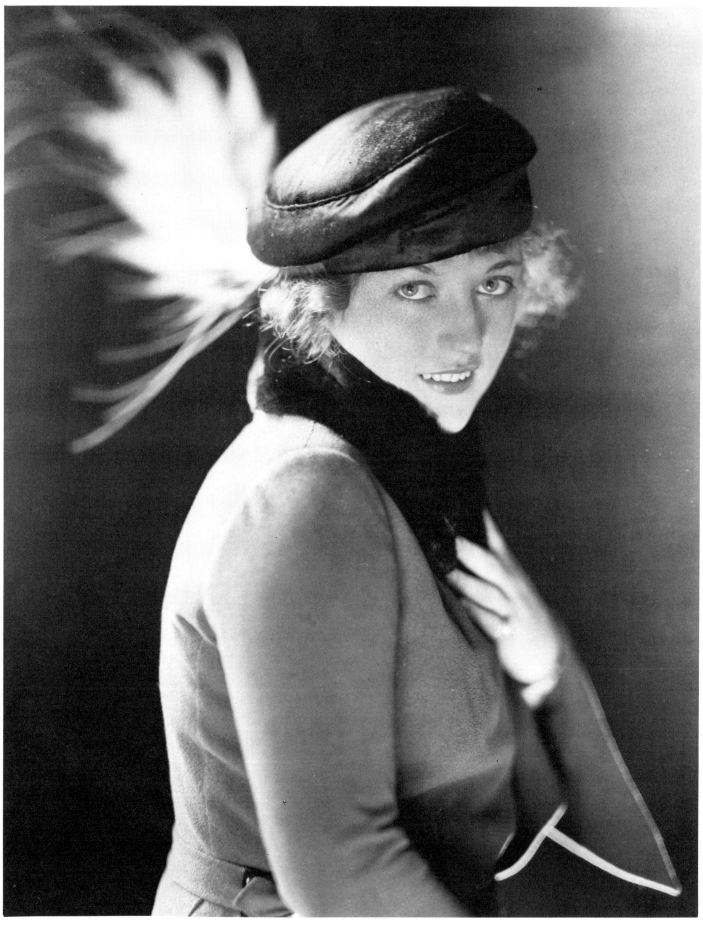

24 Marion Davies

25 Hedda Hopper

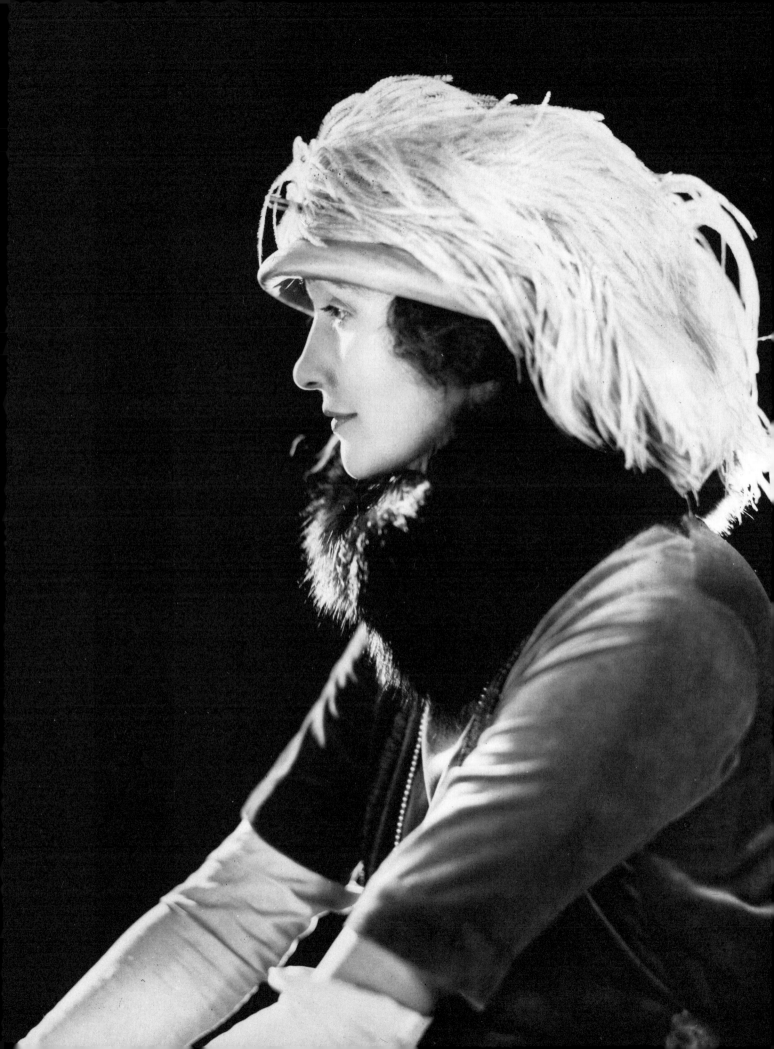

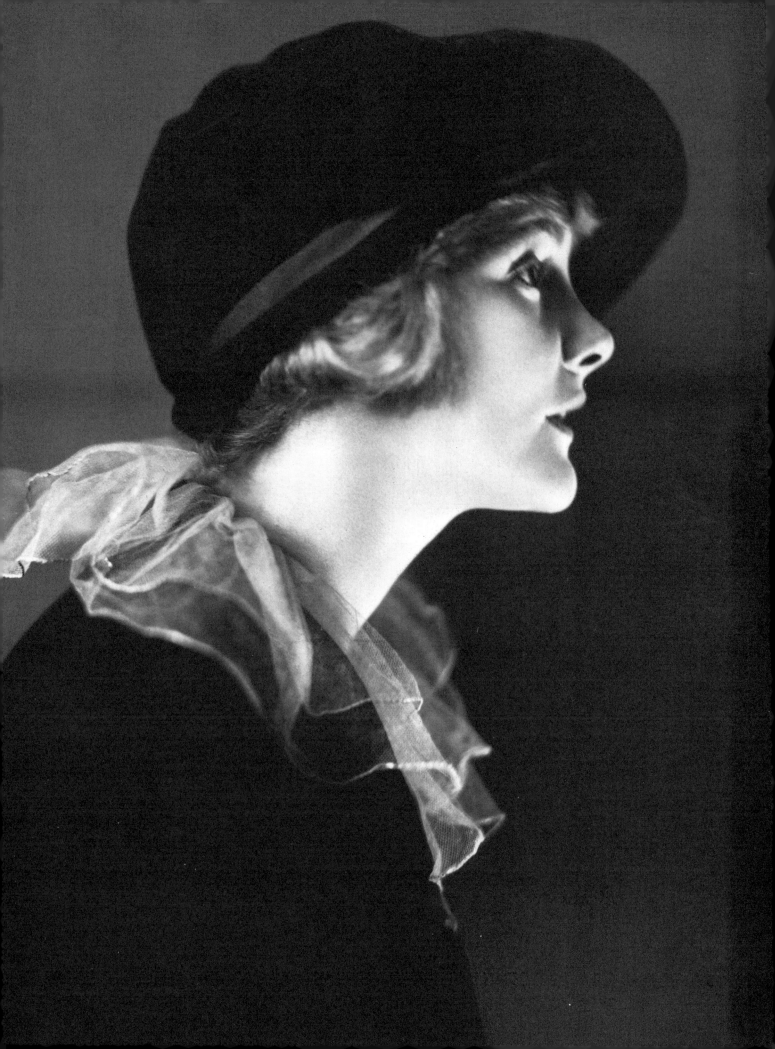

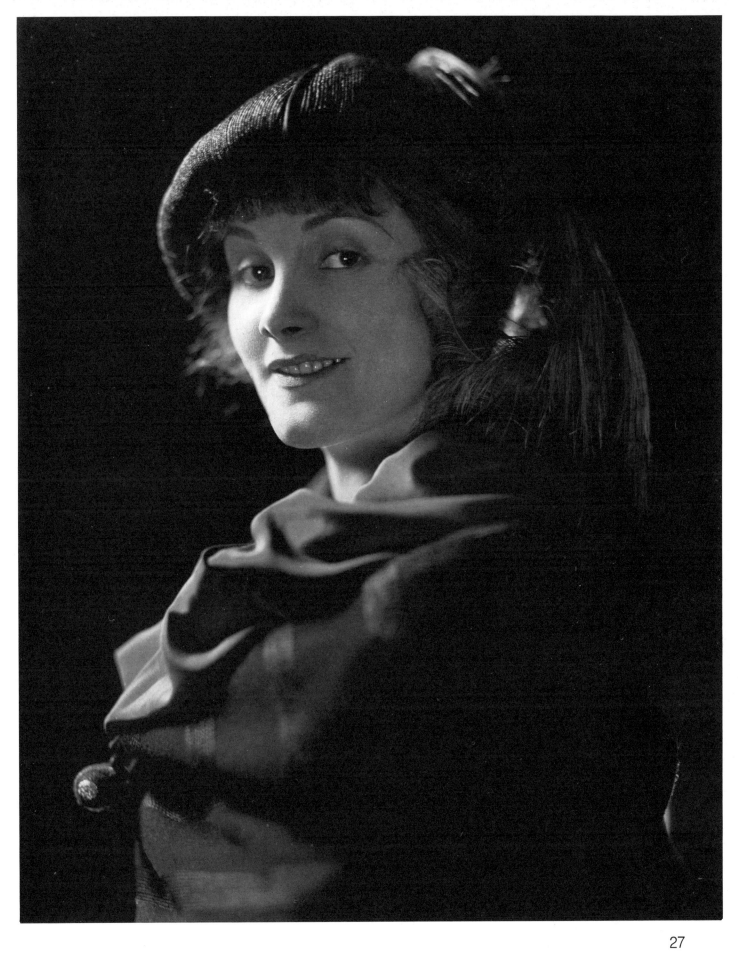

Jeanne Eagels

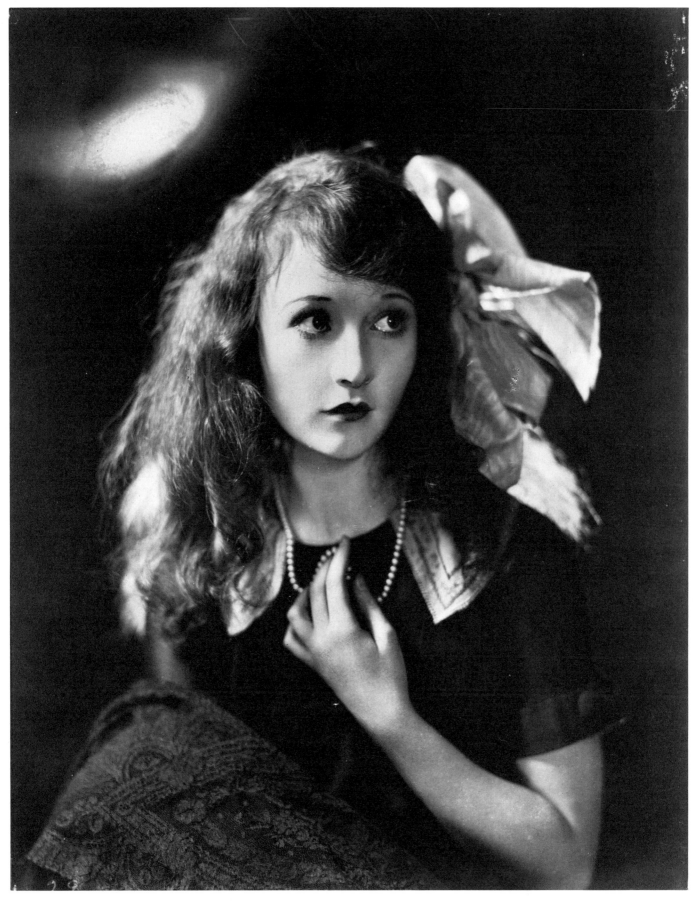

28 Betty Compson

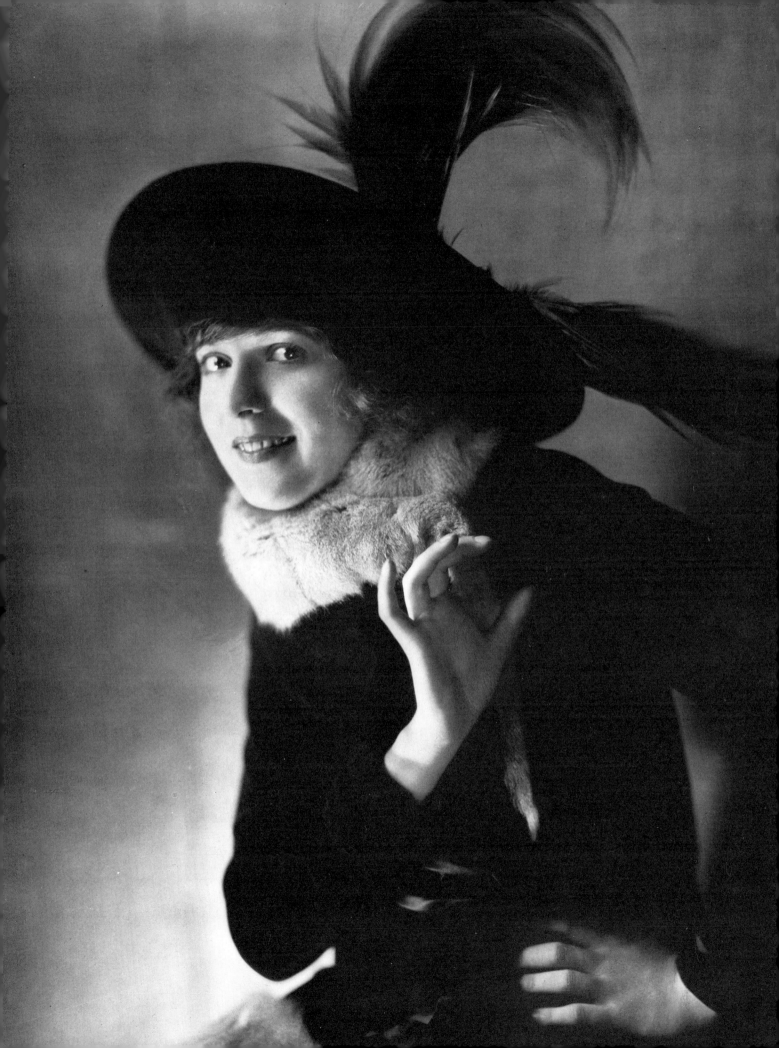

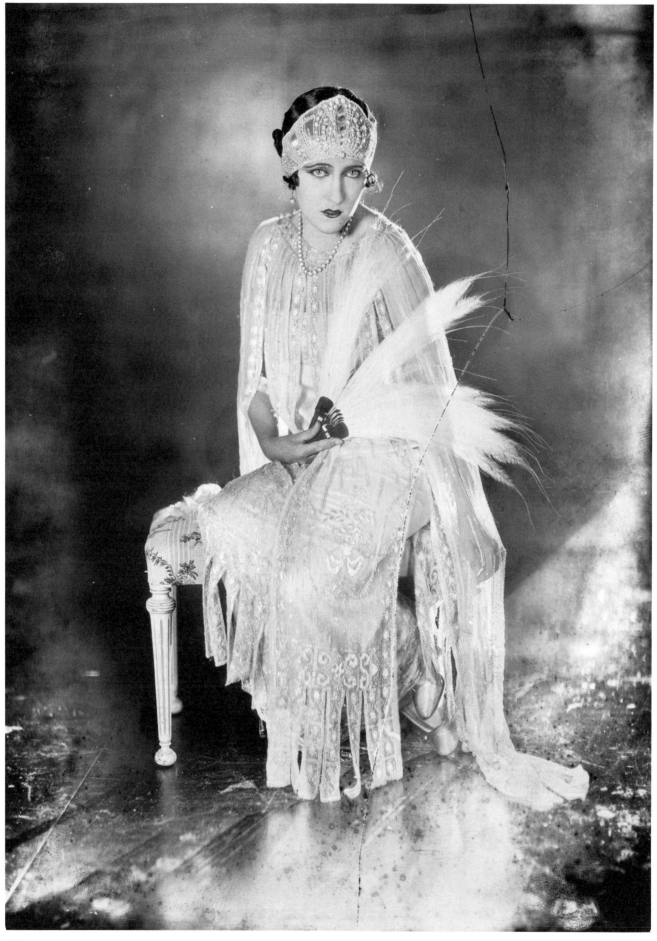

Gloria Swanson

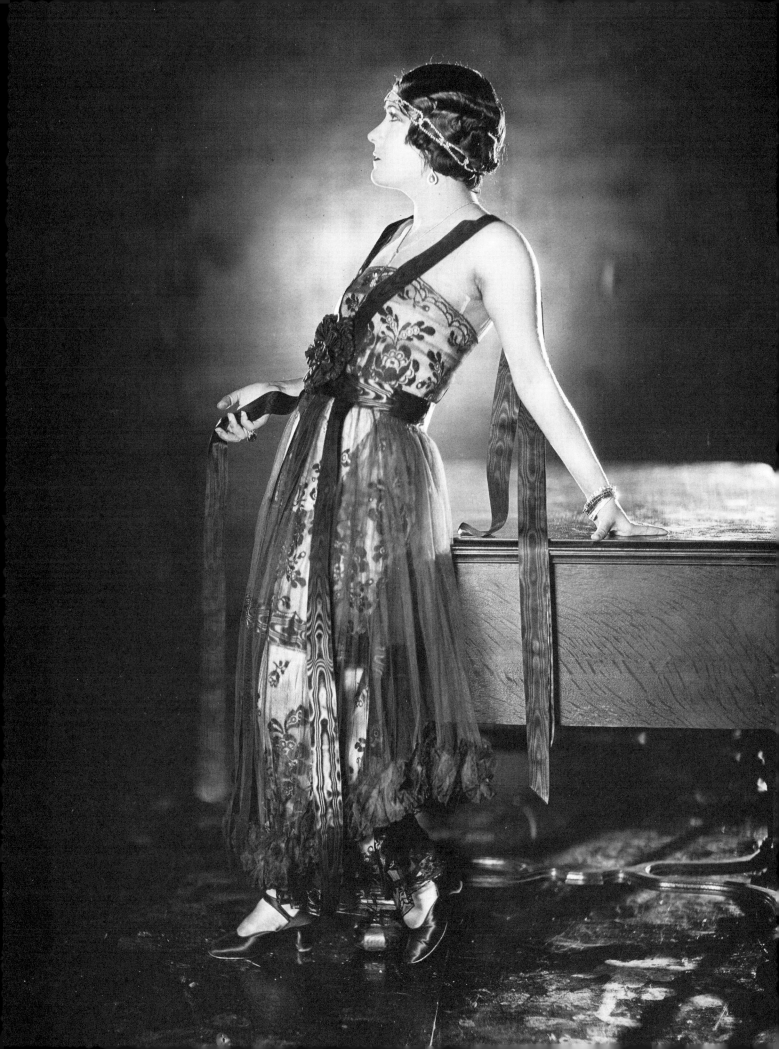

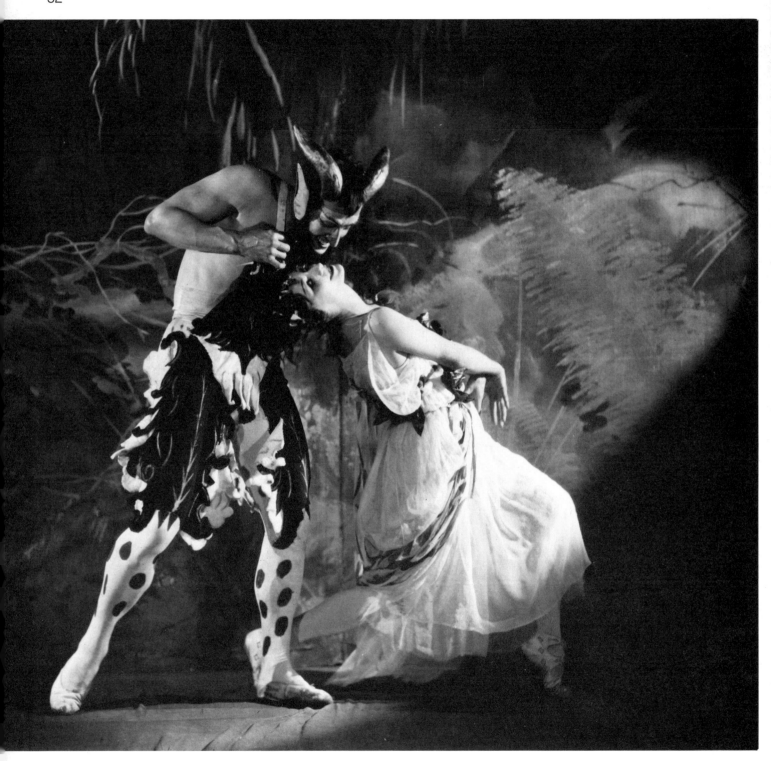

34 Nijinska

35 Lubov Tchernicheva

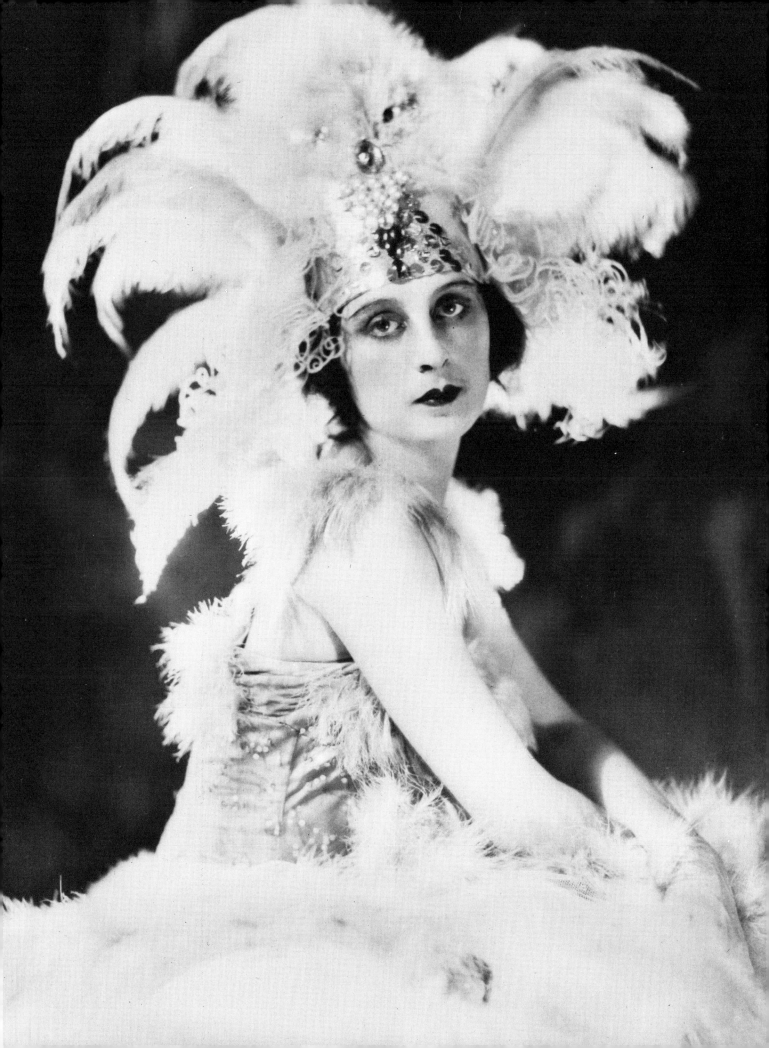

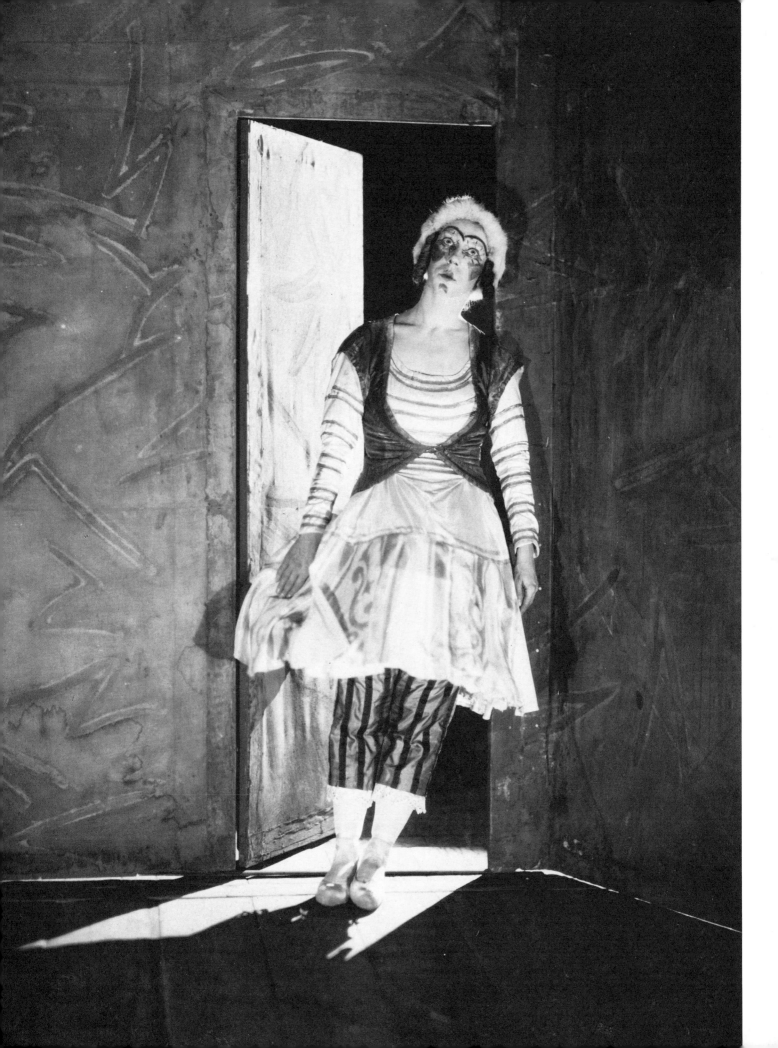

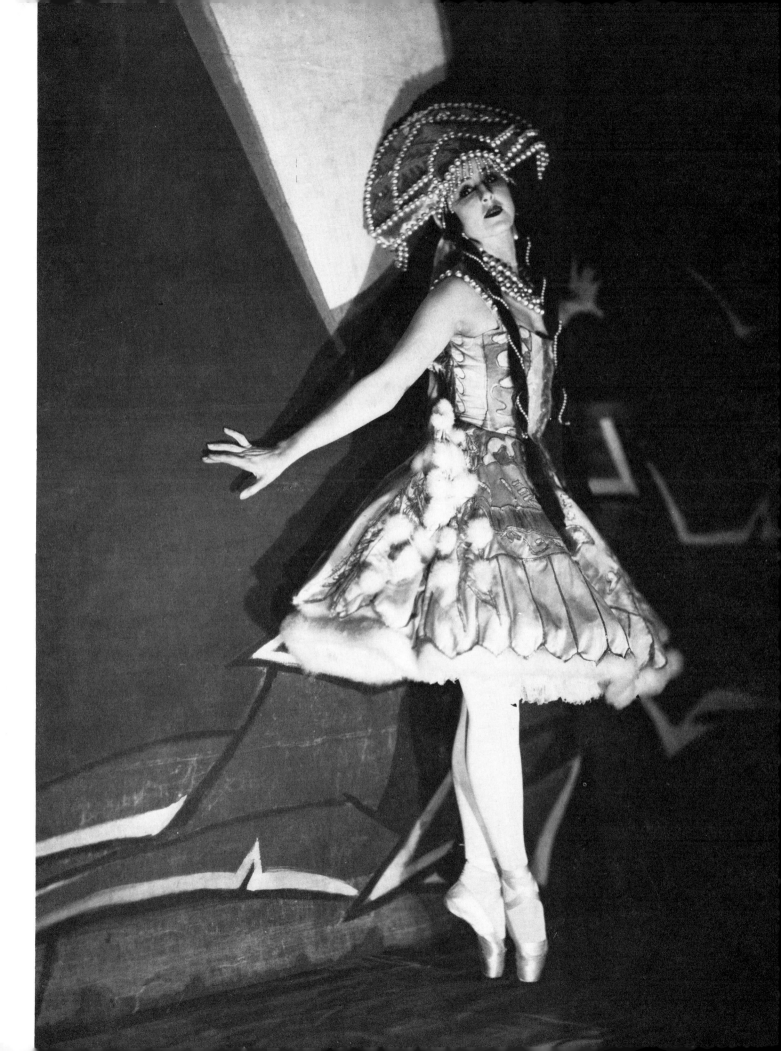

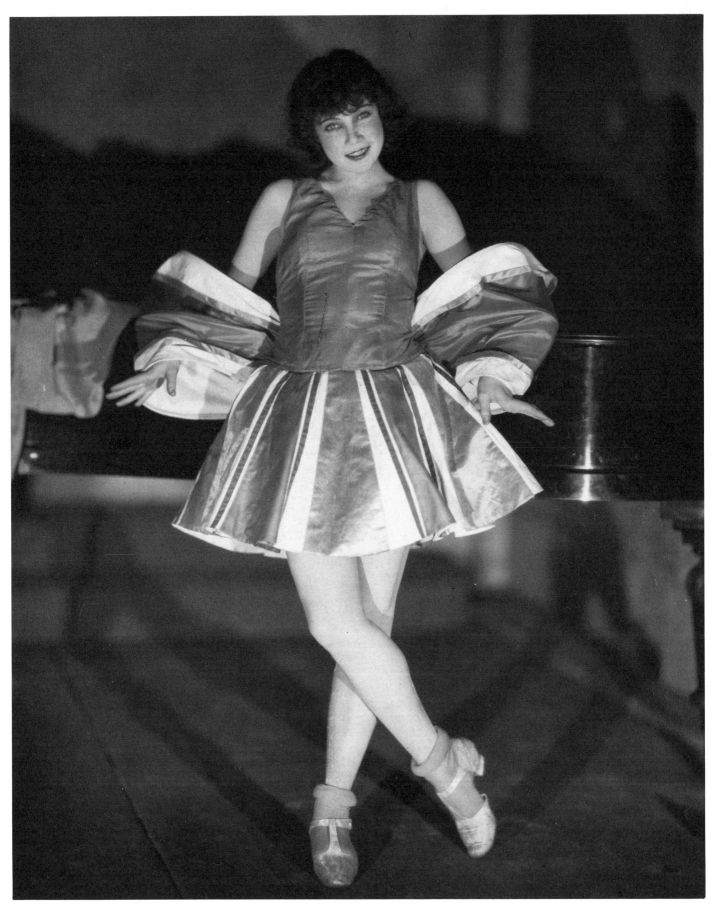

36 Tilly Losch

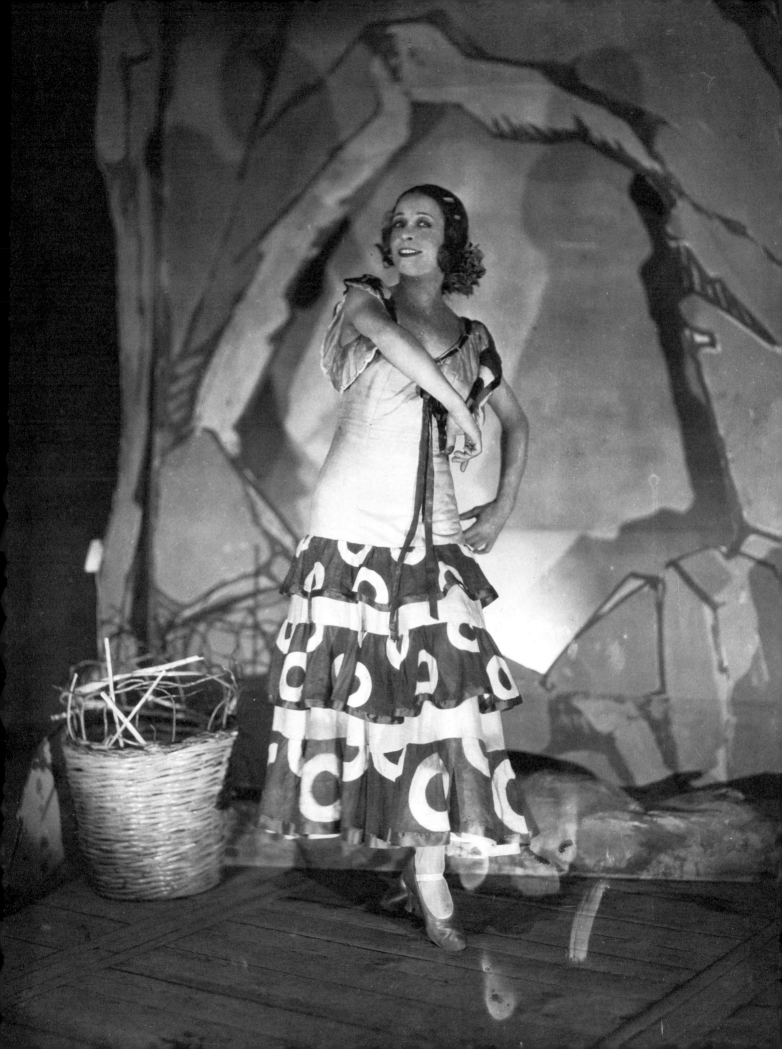

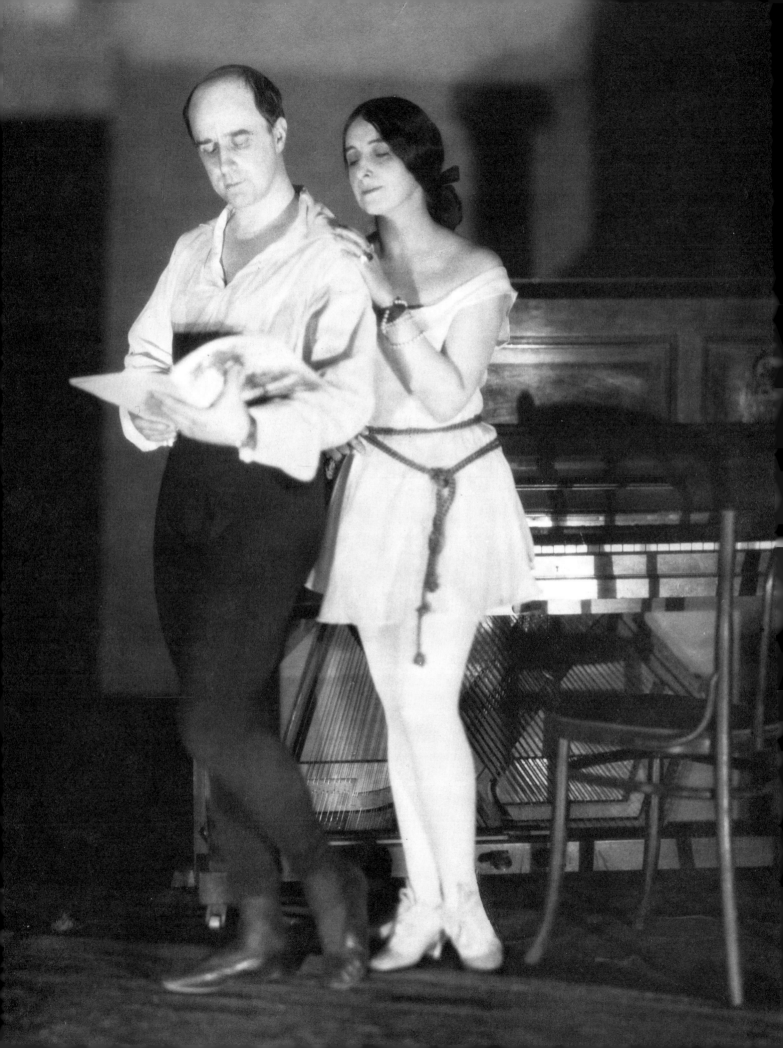

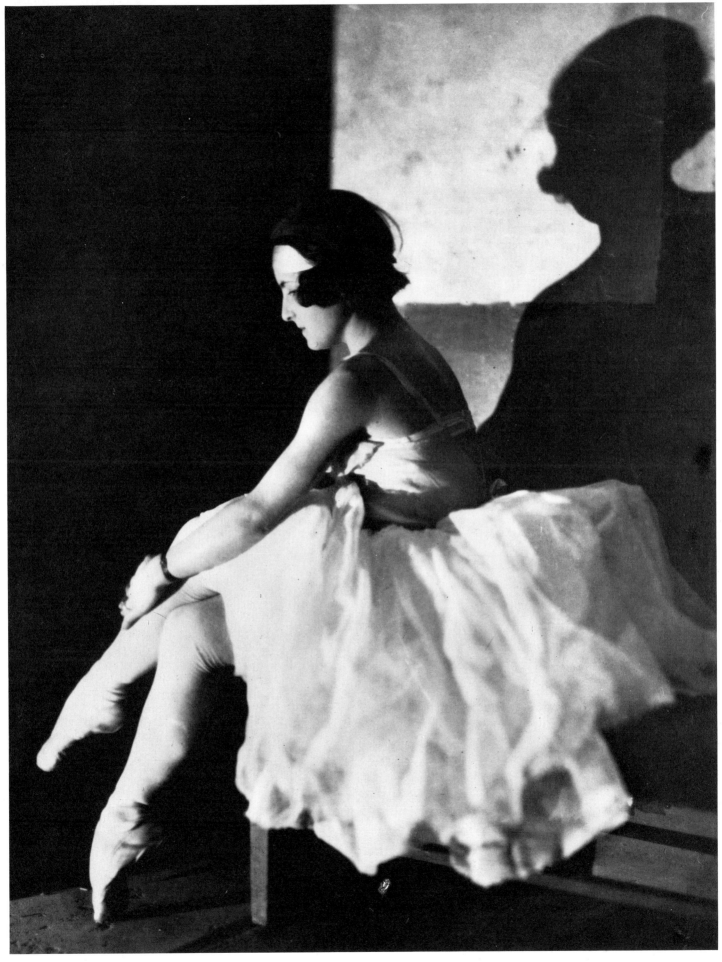

38 Fokine, Fokina

39 Lucette Baudier

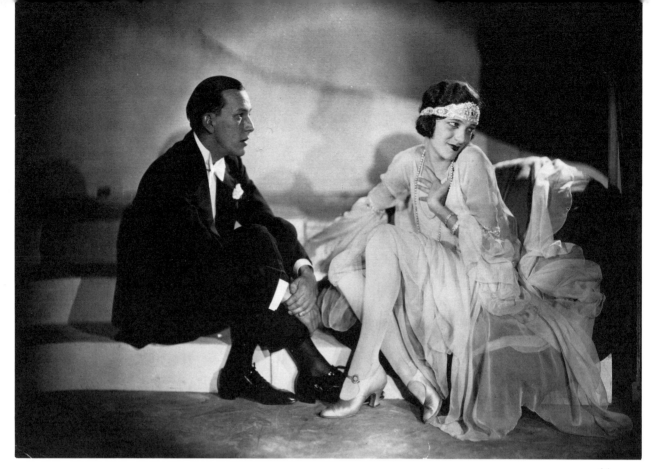

41

40

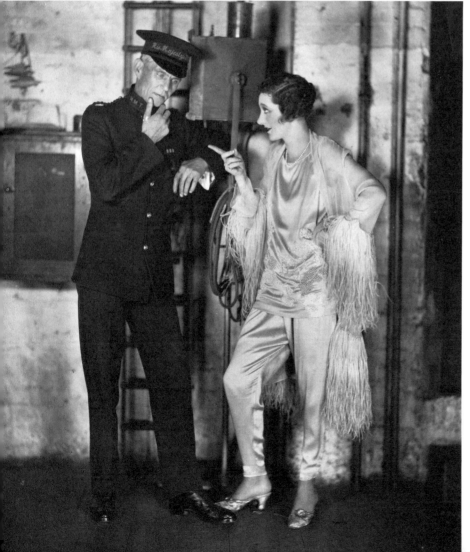

Noël Coward, Gertrude Lawrence

42

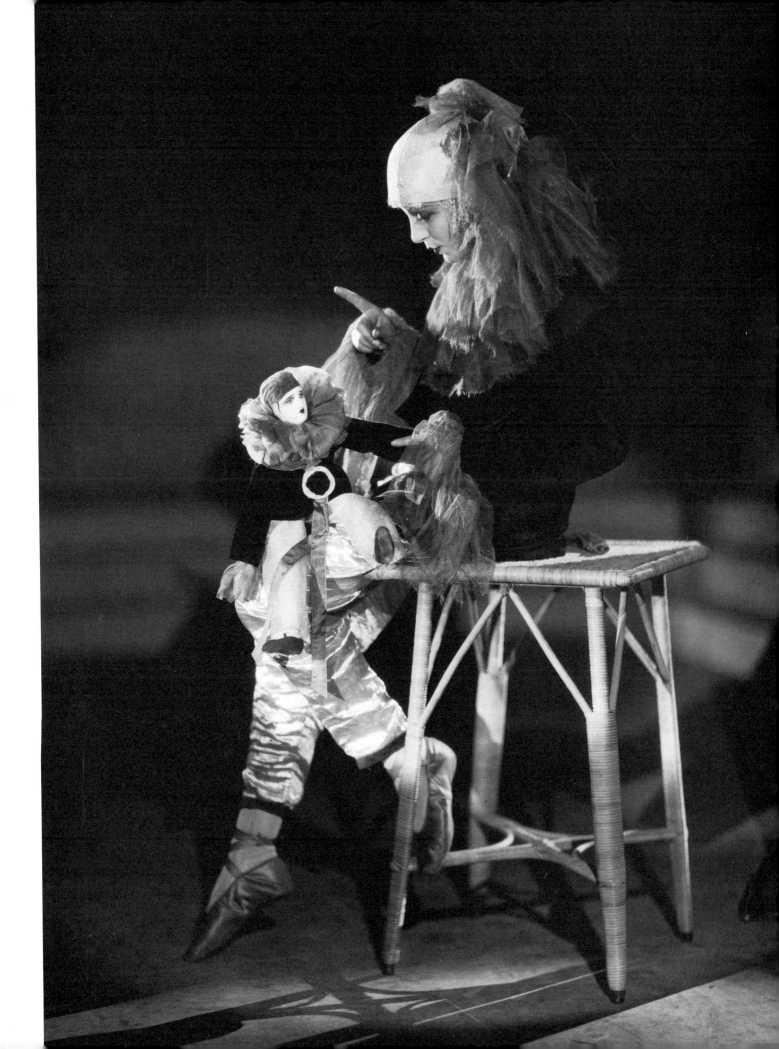

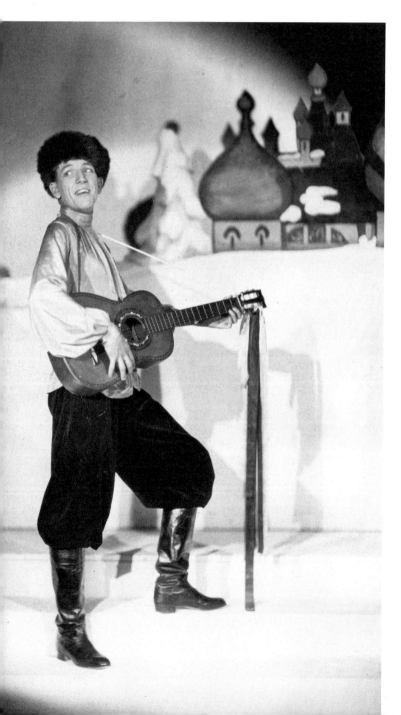

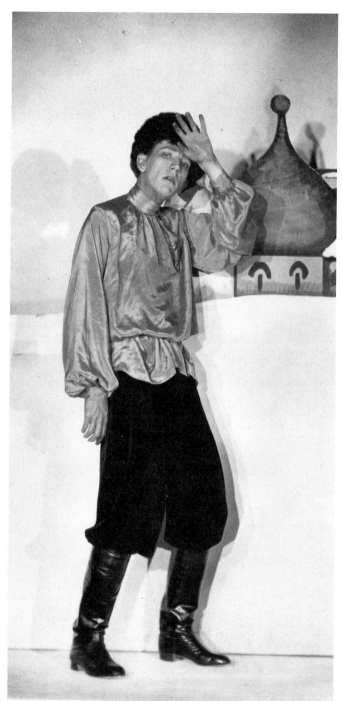

44

Noël Coward, Gertrude Lawrence

43

45

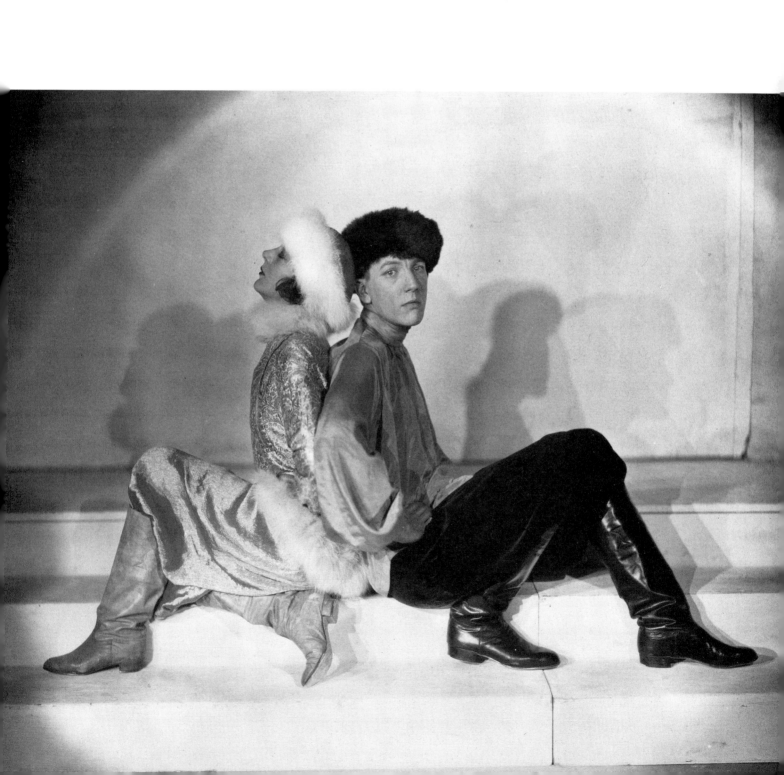

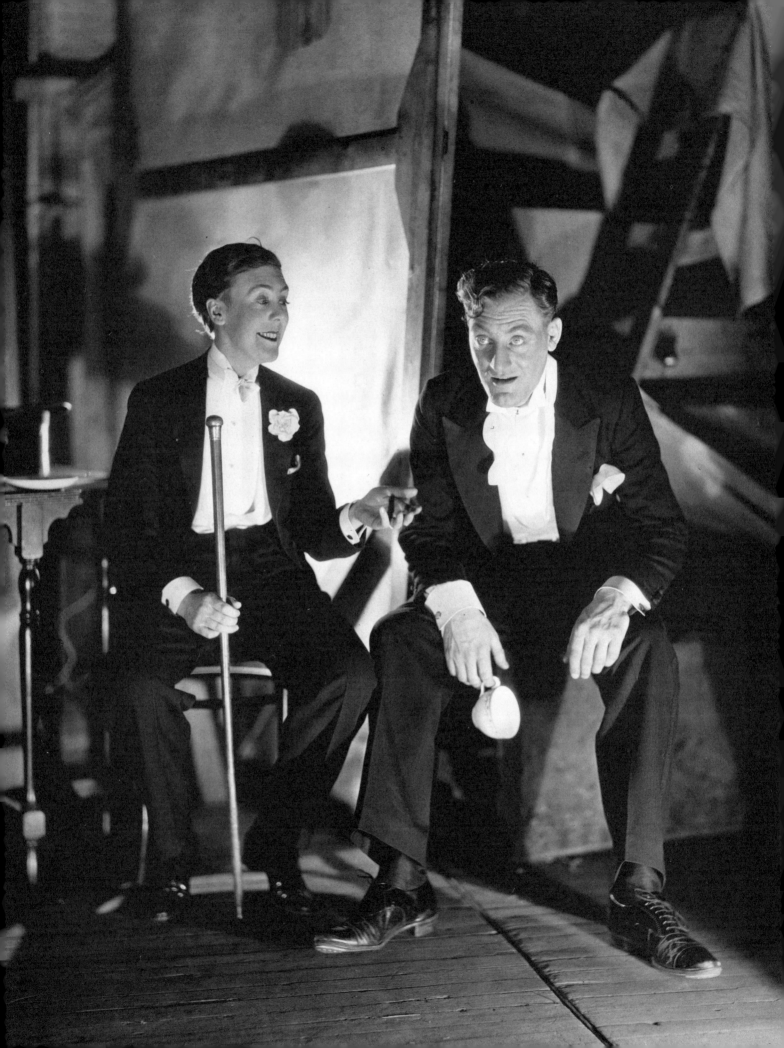

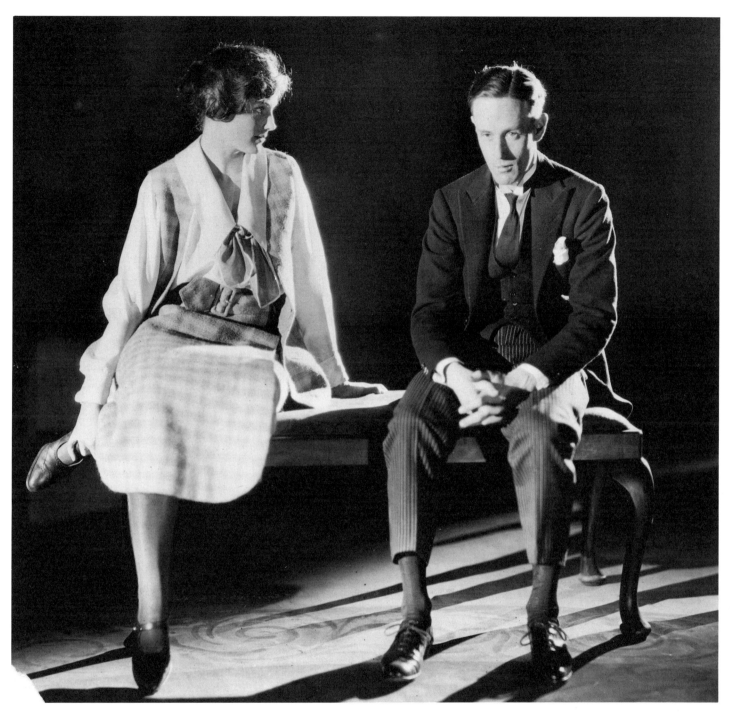

47 Alexandra Carlisle, Leslie Howard

46 Cicely Courtneidge, Charles Courtneidge

Adele Astaire, Fred Astaire

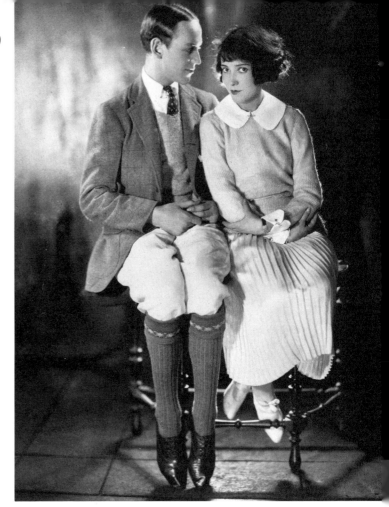

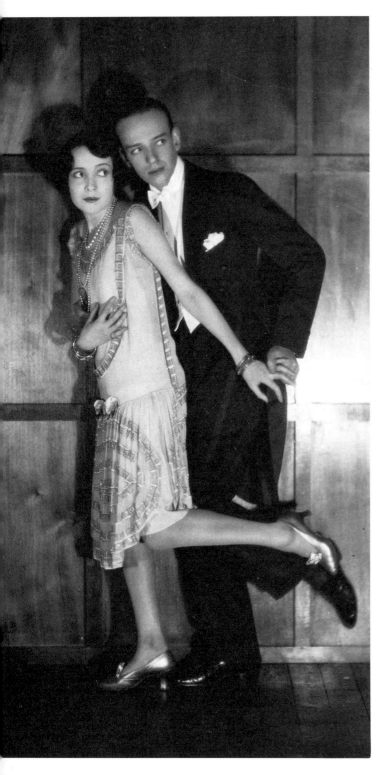

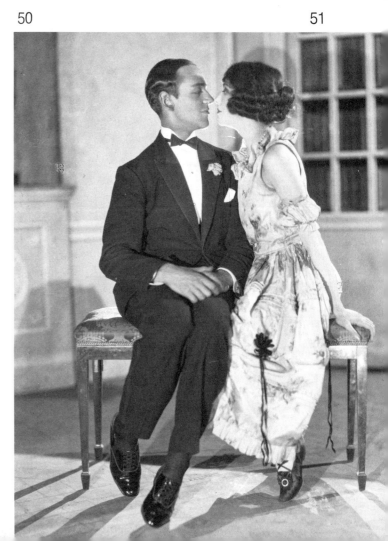

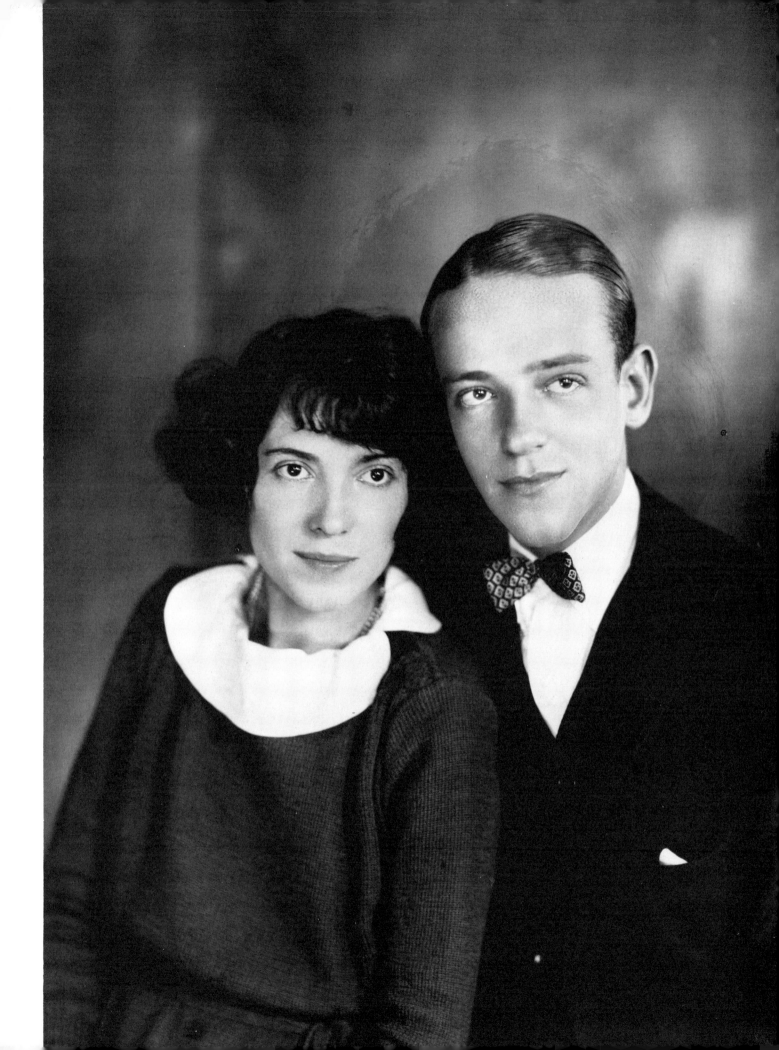

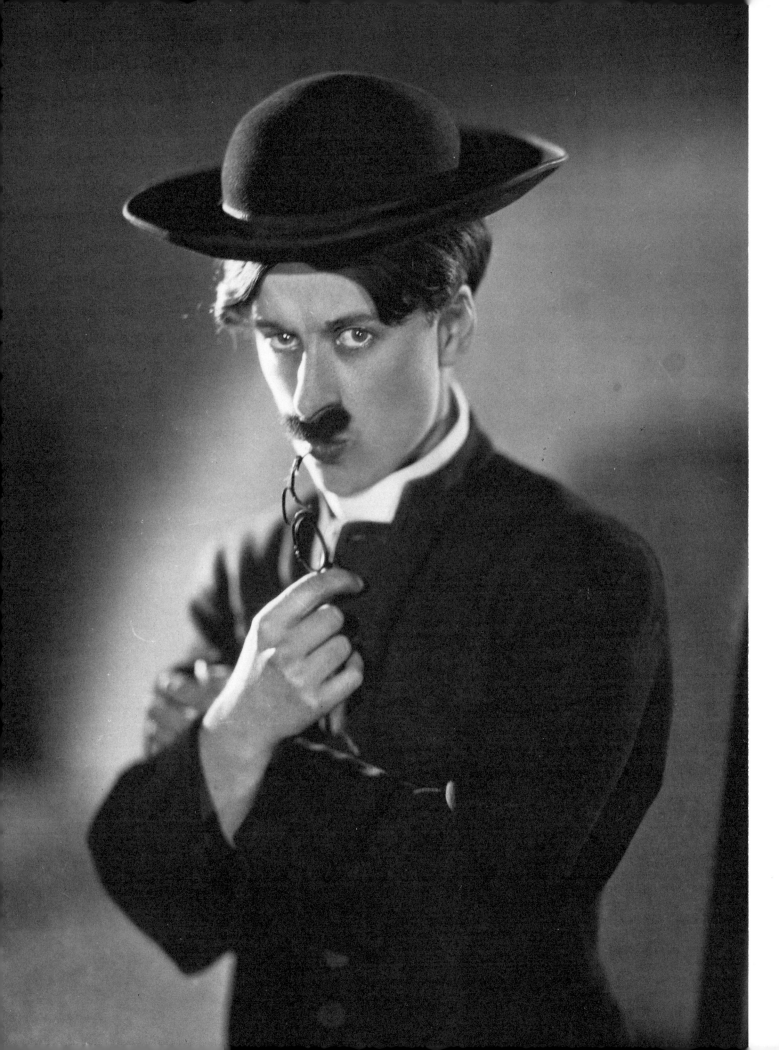

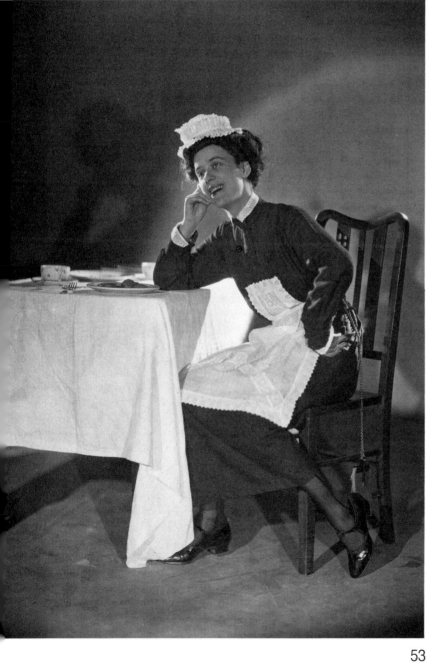

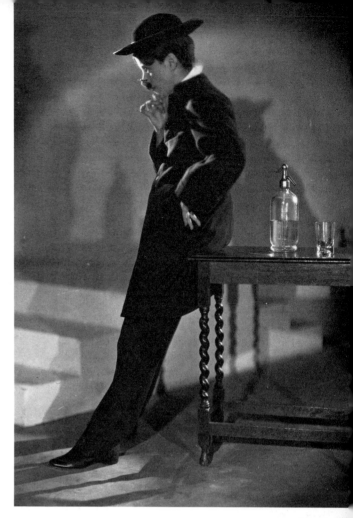

54

53

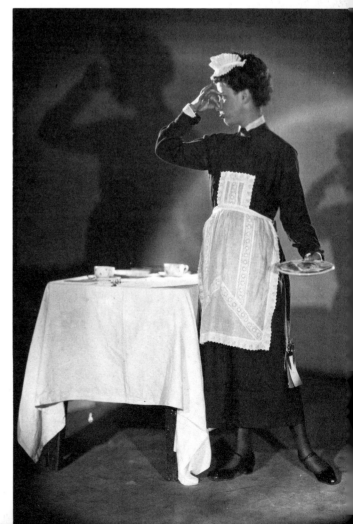

52 Beatrice Lillie

55

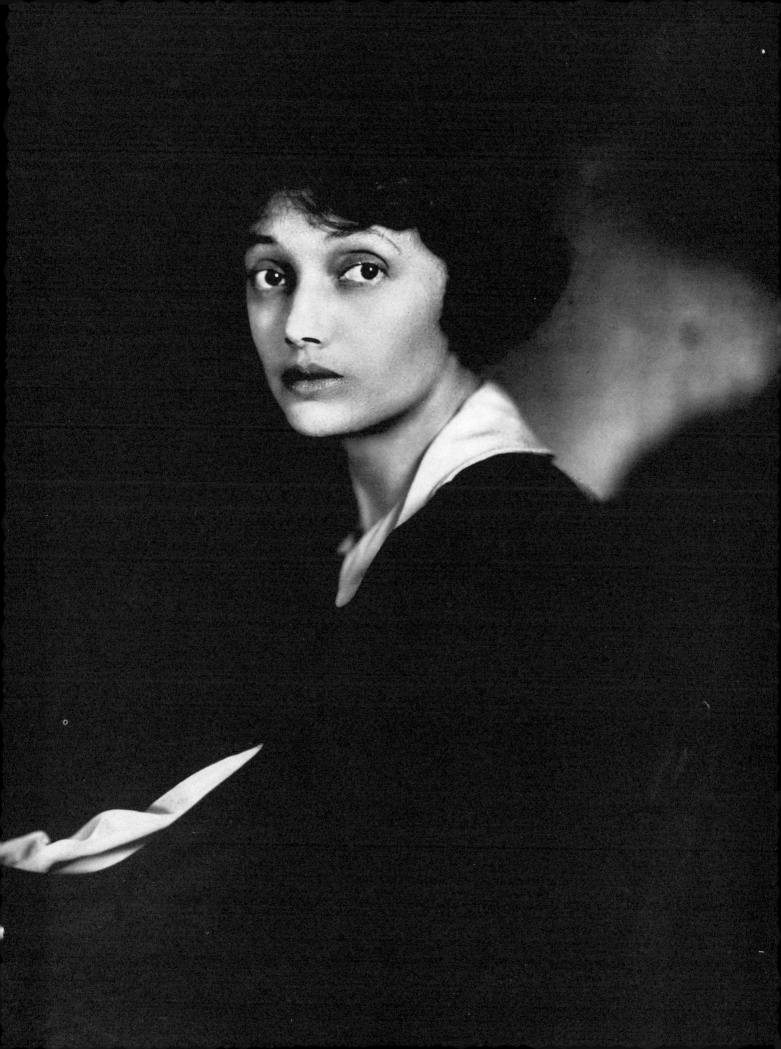

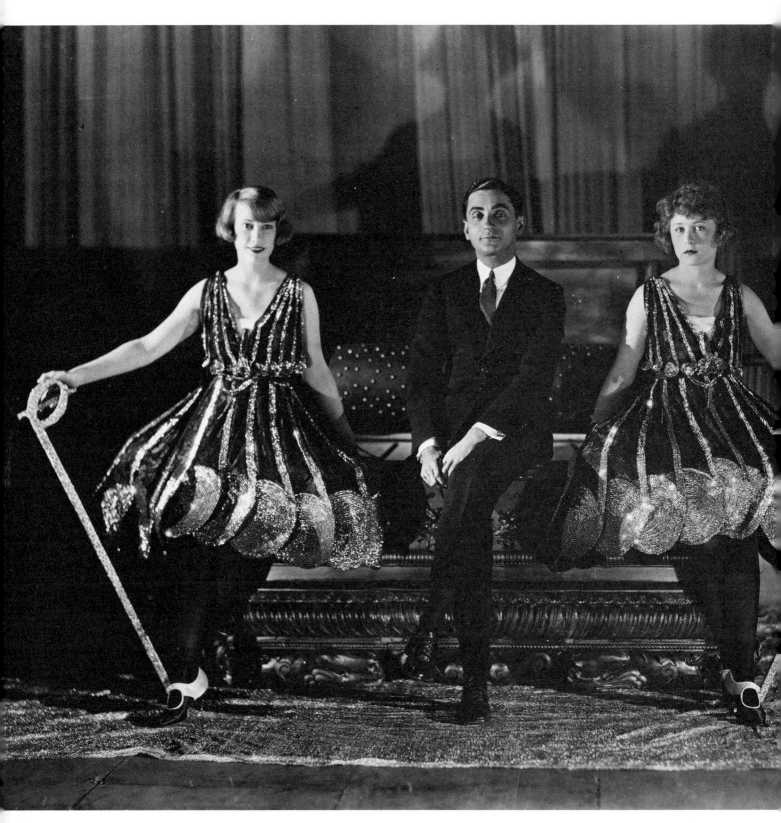

57 Irving Berlin

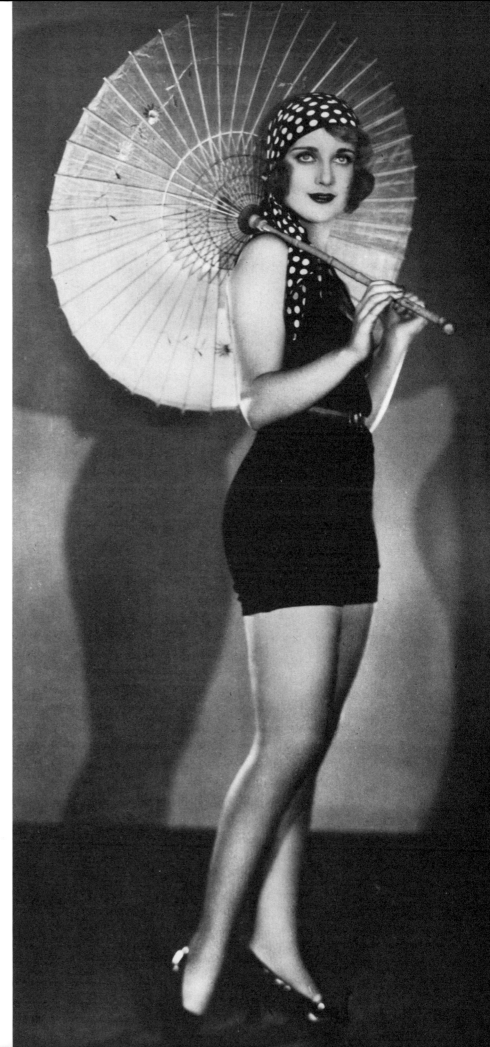

58 Carole Lombard

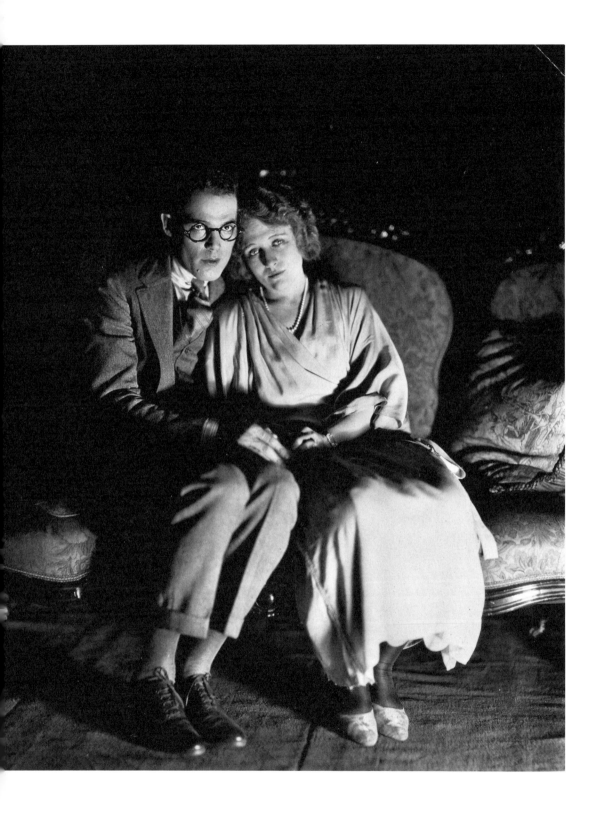

59 Henry Hull, Florence Eldridge

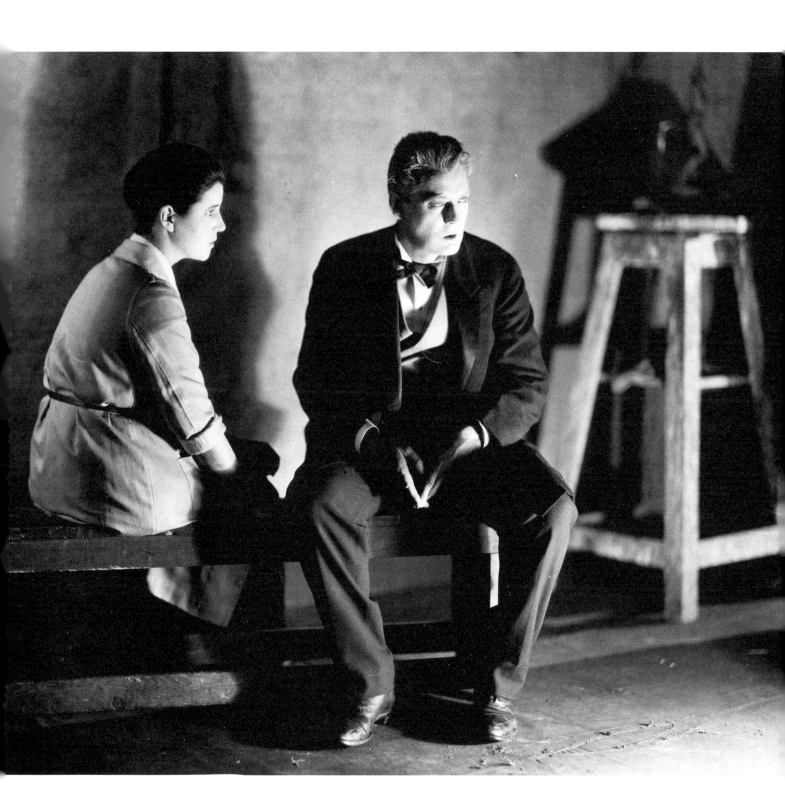

60 Irene Fenwick, Lionel Barrymore

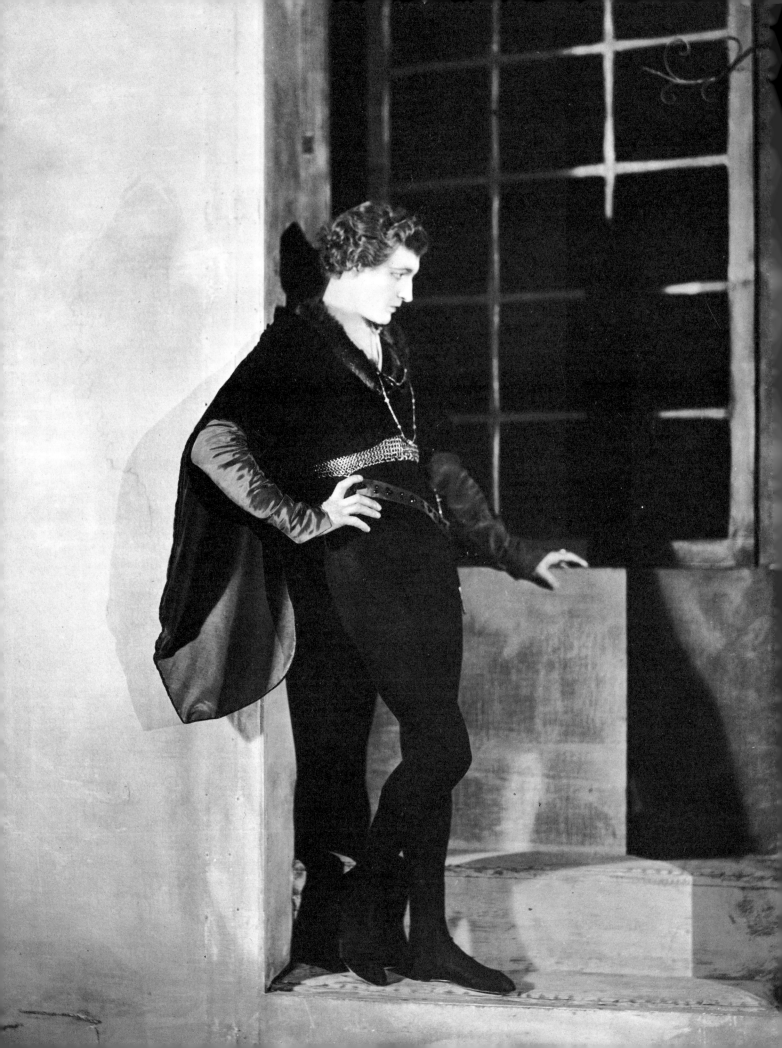

61

John Barrymore

62

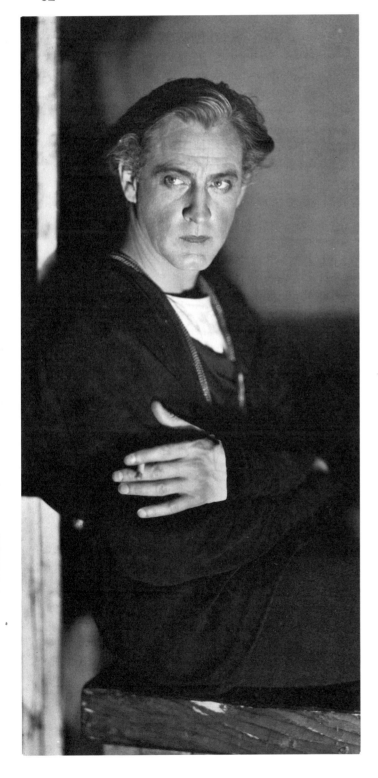

63

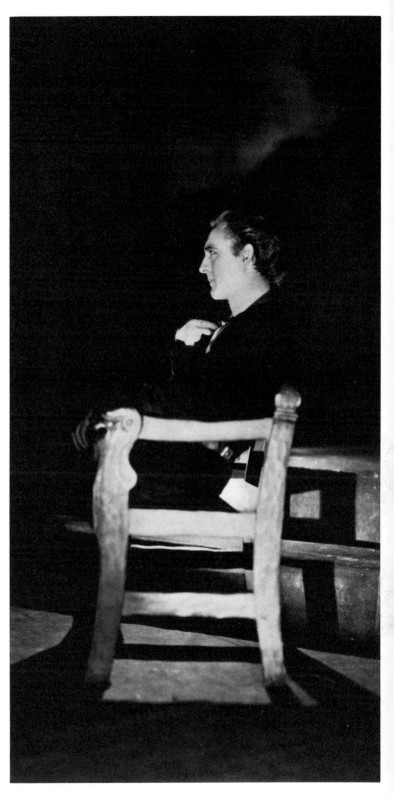

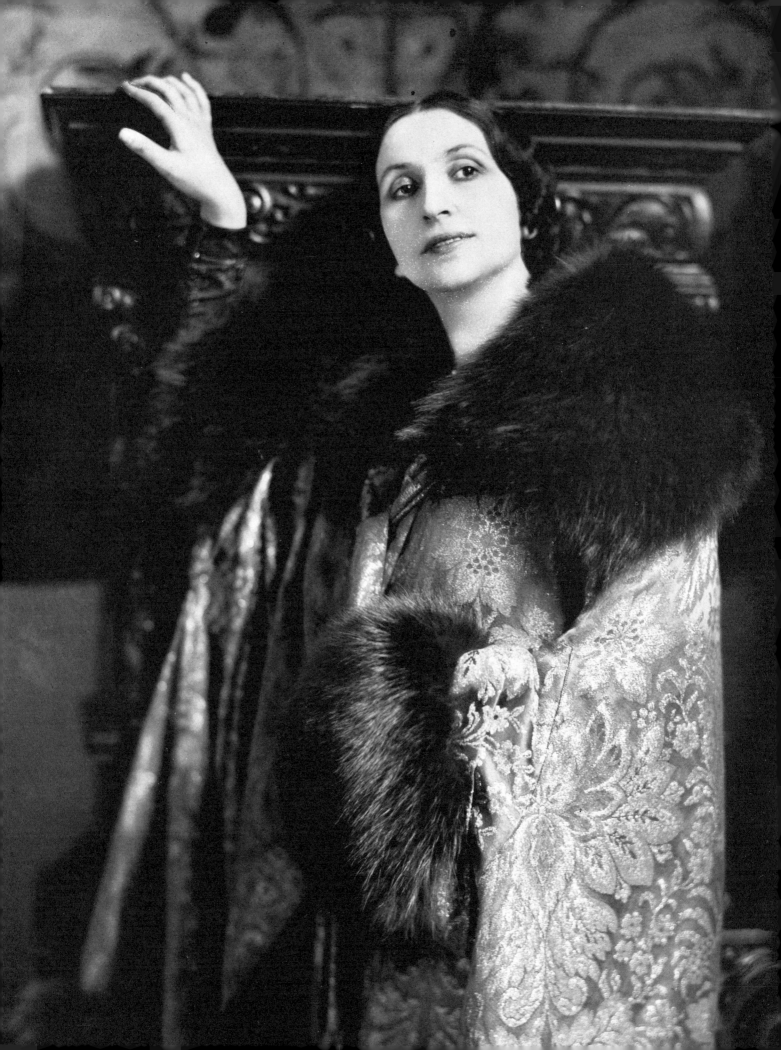

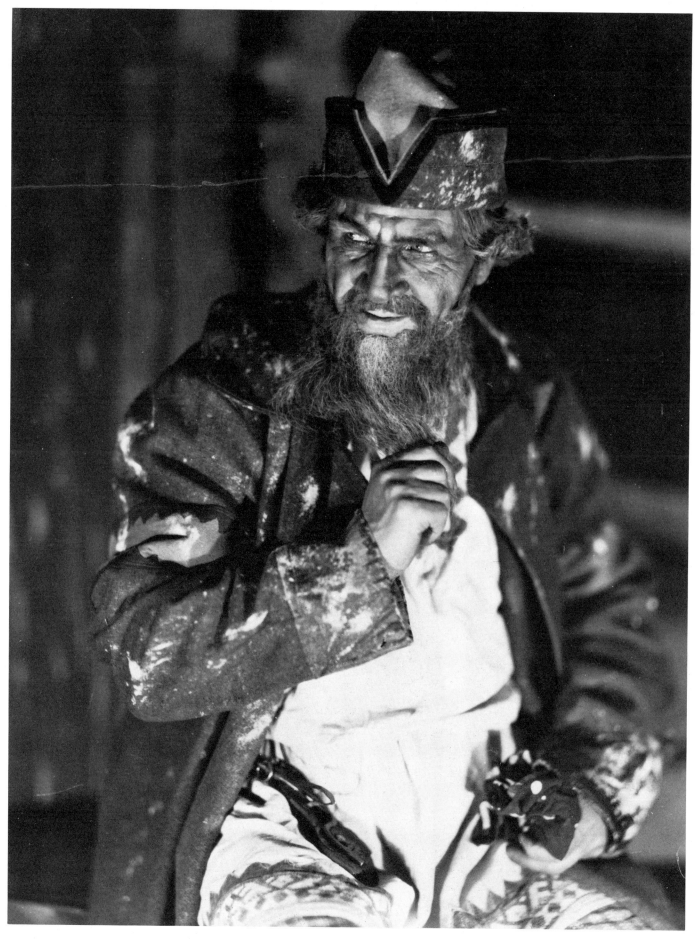

64 Amelita Galli-Curci

65 Feodor Chaliapin

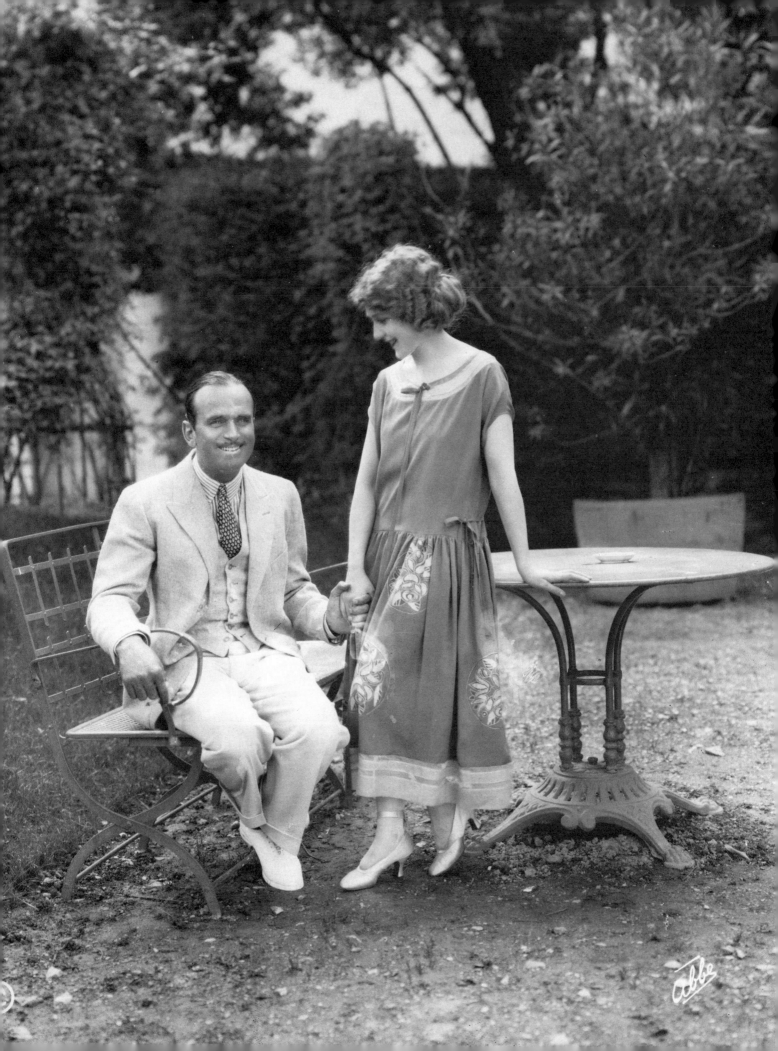

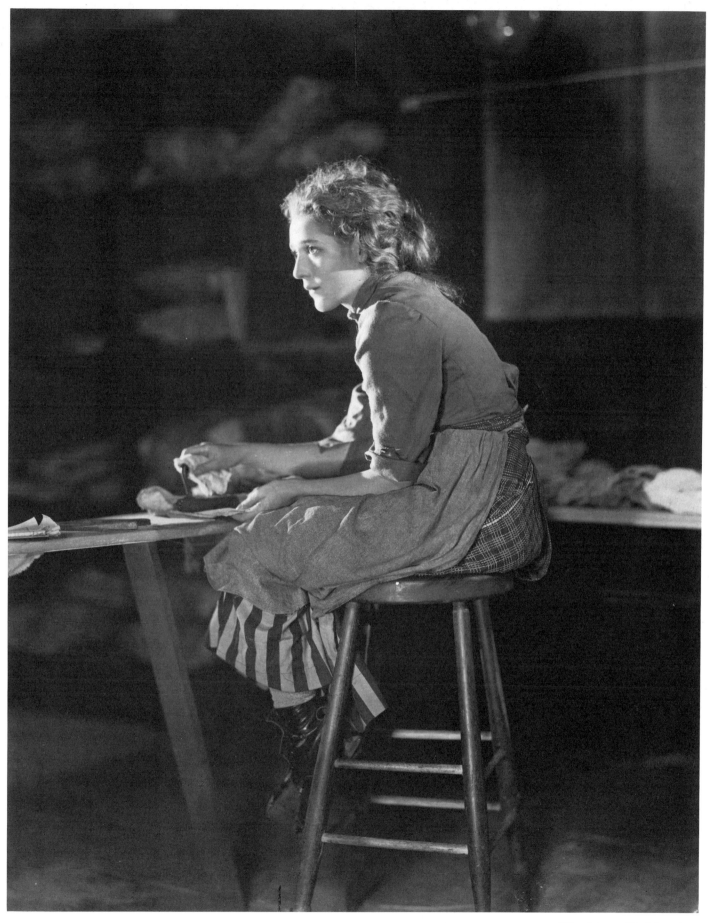

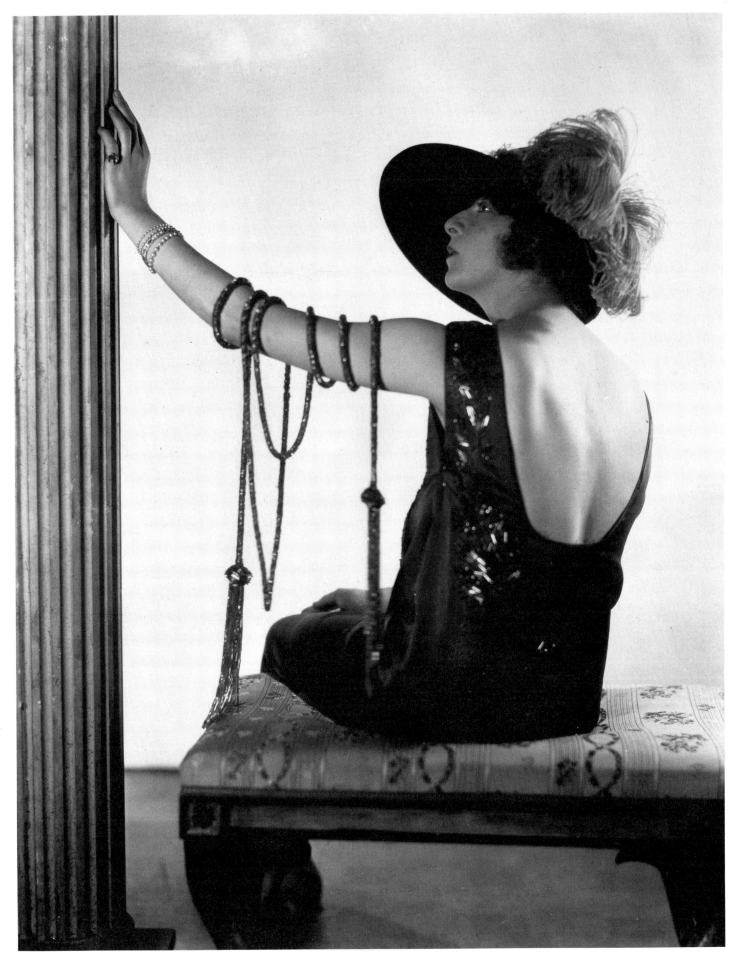

68 Fanny Brice

69 Billie Burke

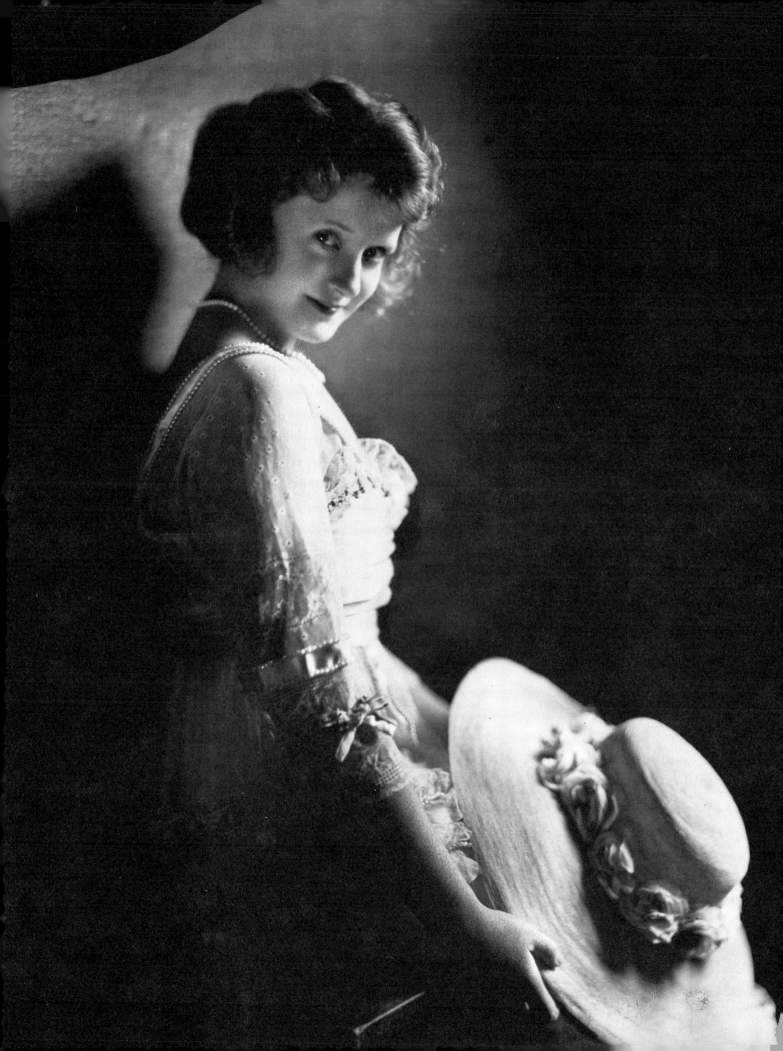

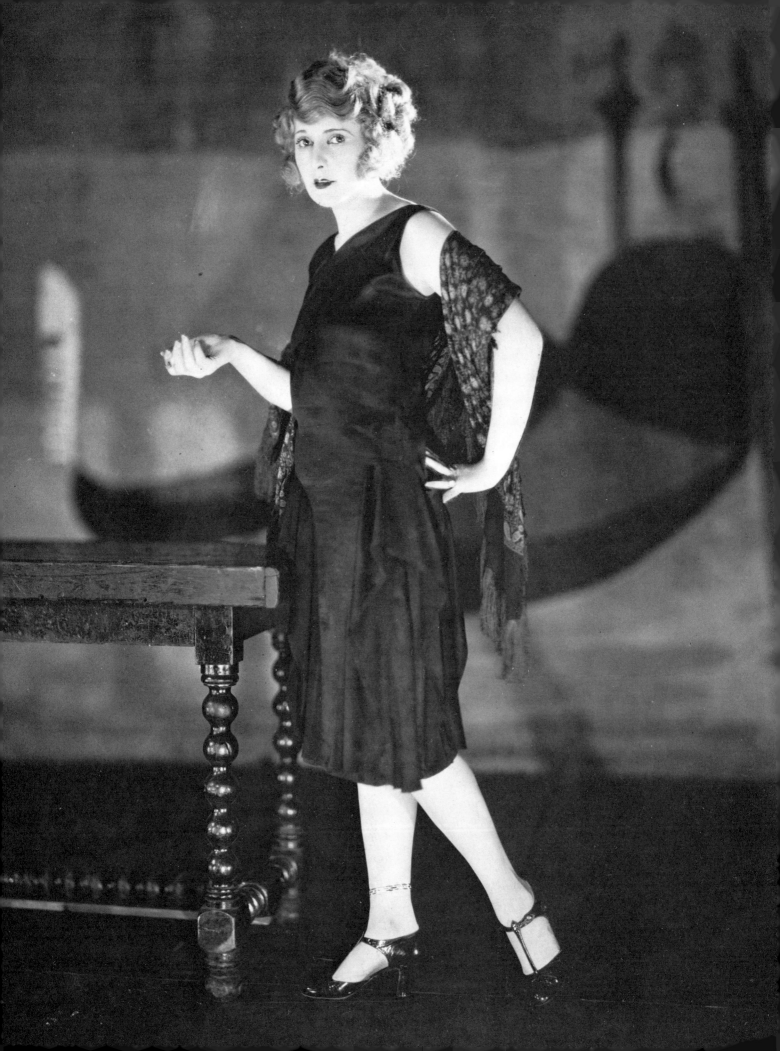

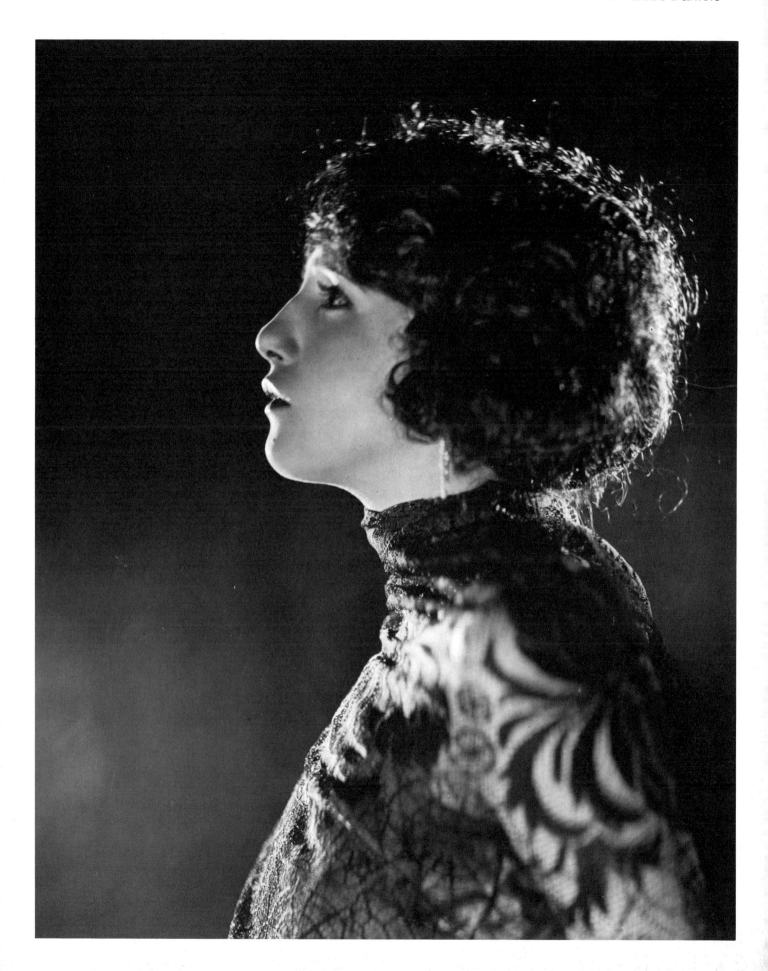

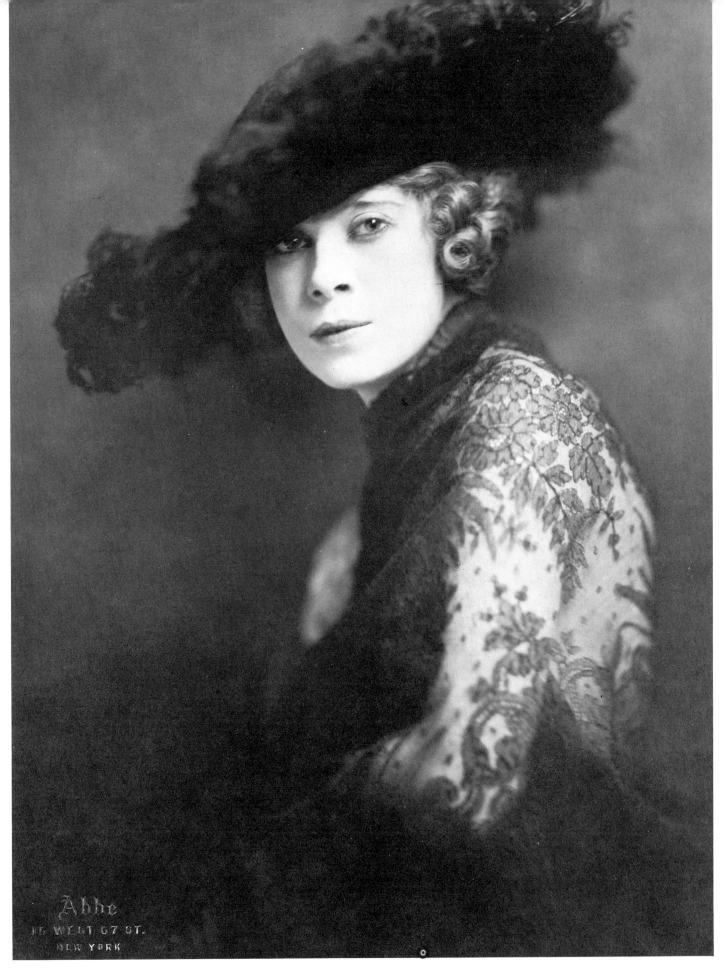

Abbe
16 WEST 67 ST.
NEW YORK

72 Mae West 73 Tallulah Bankhead

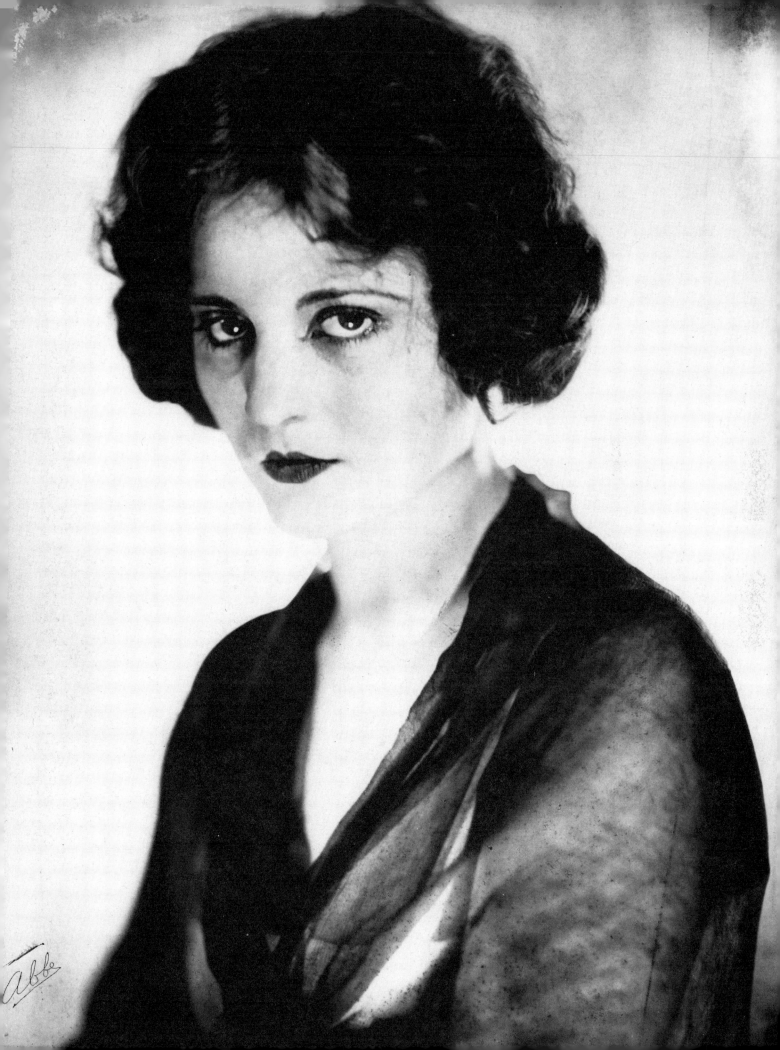

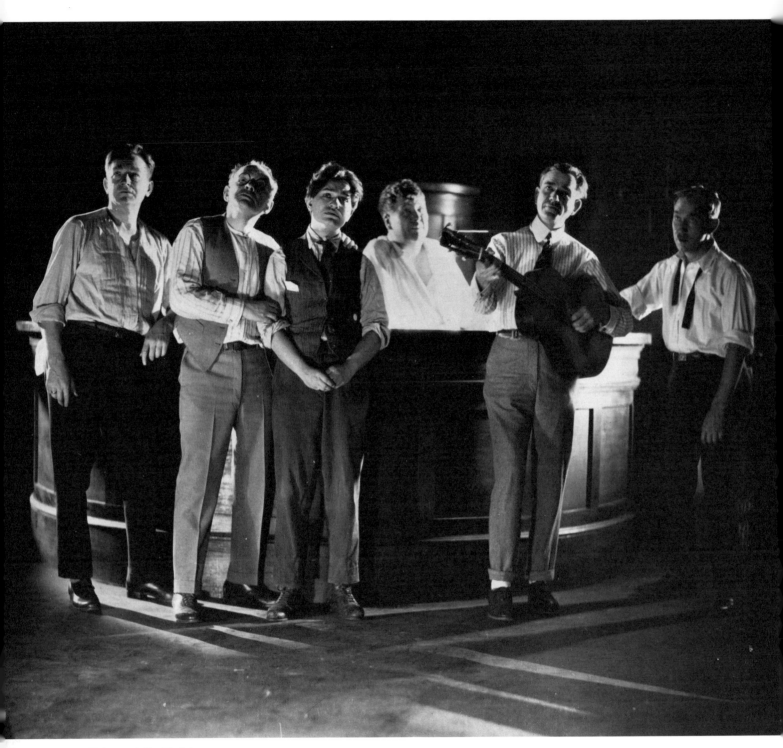

74 Edward G. Robinson

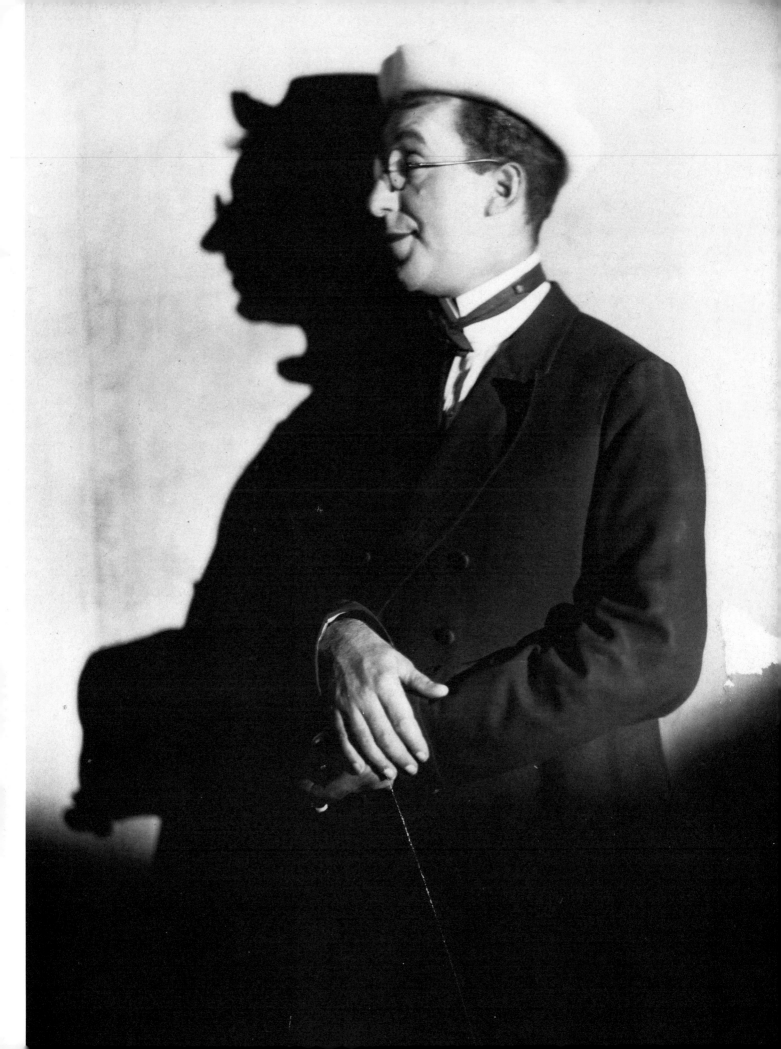

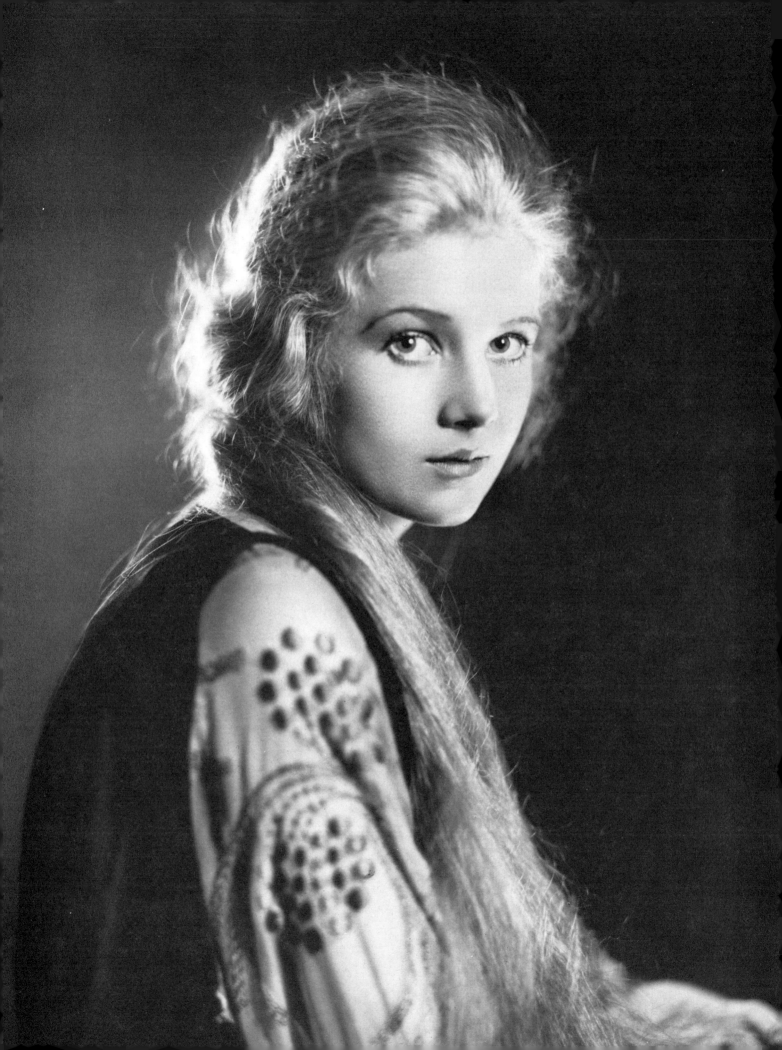

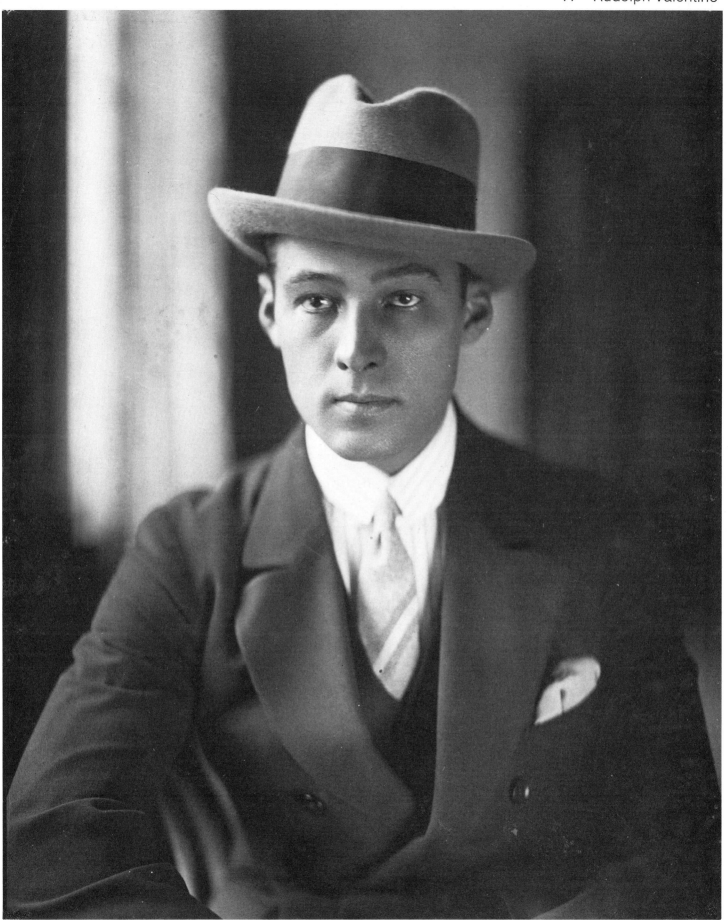

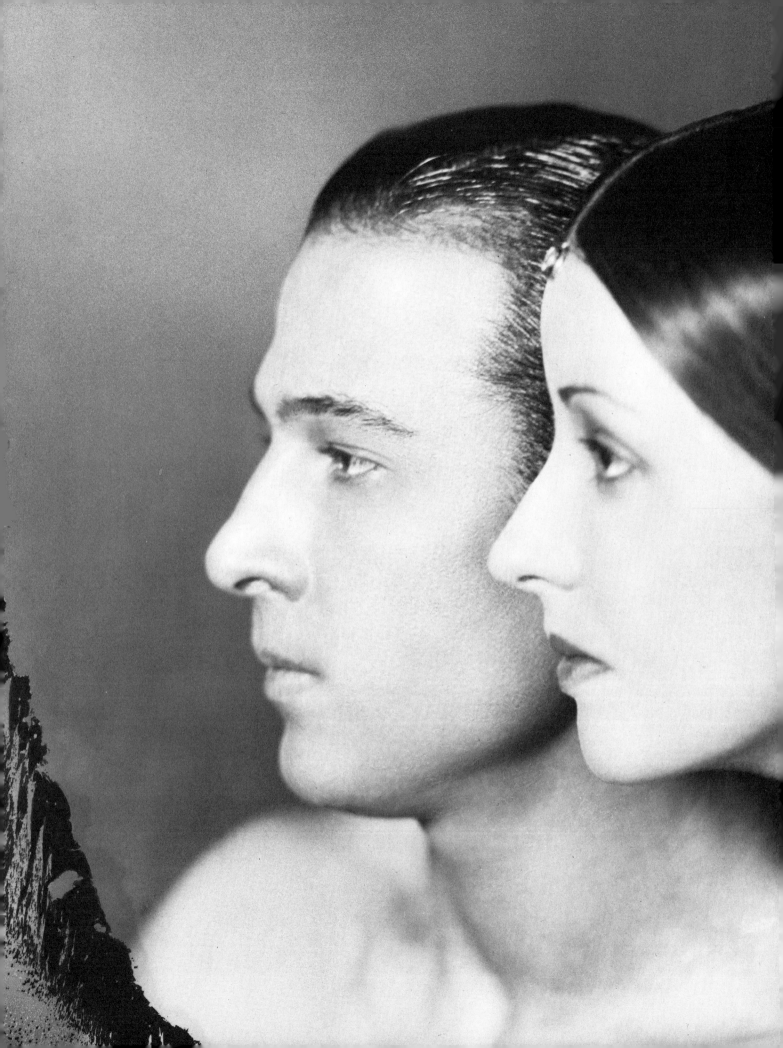

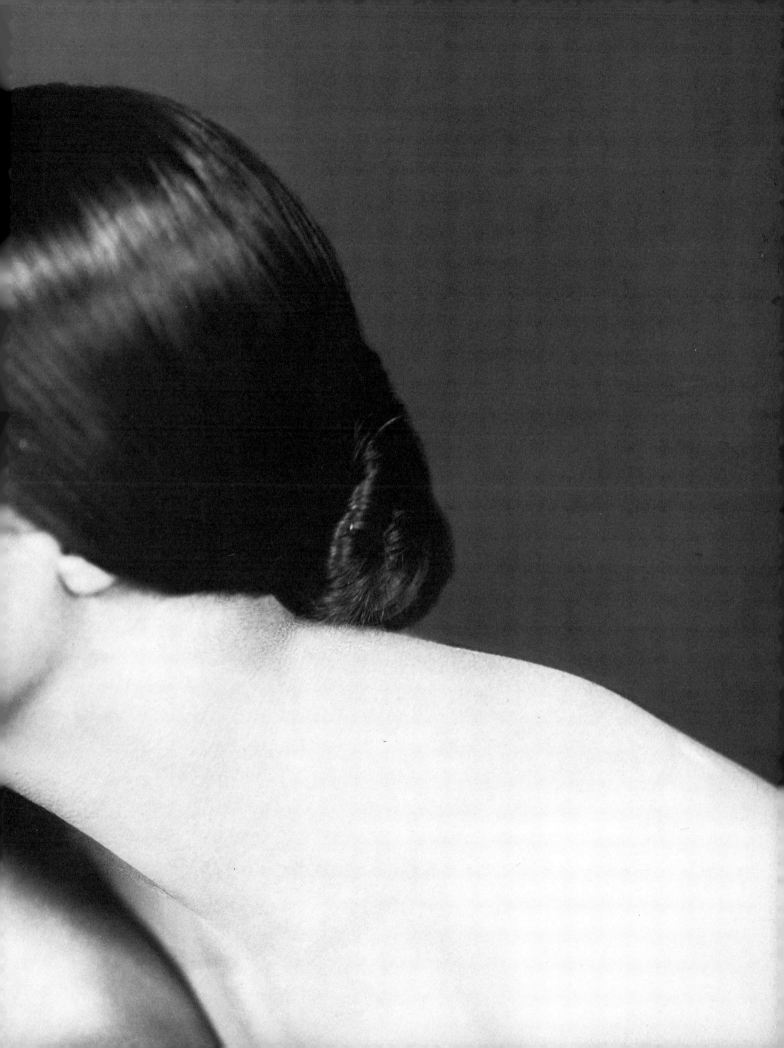

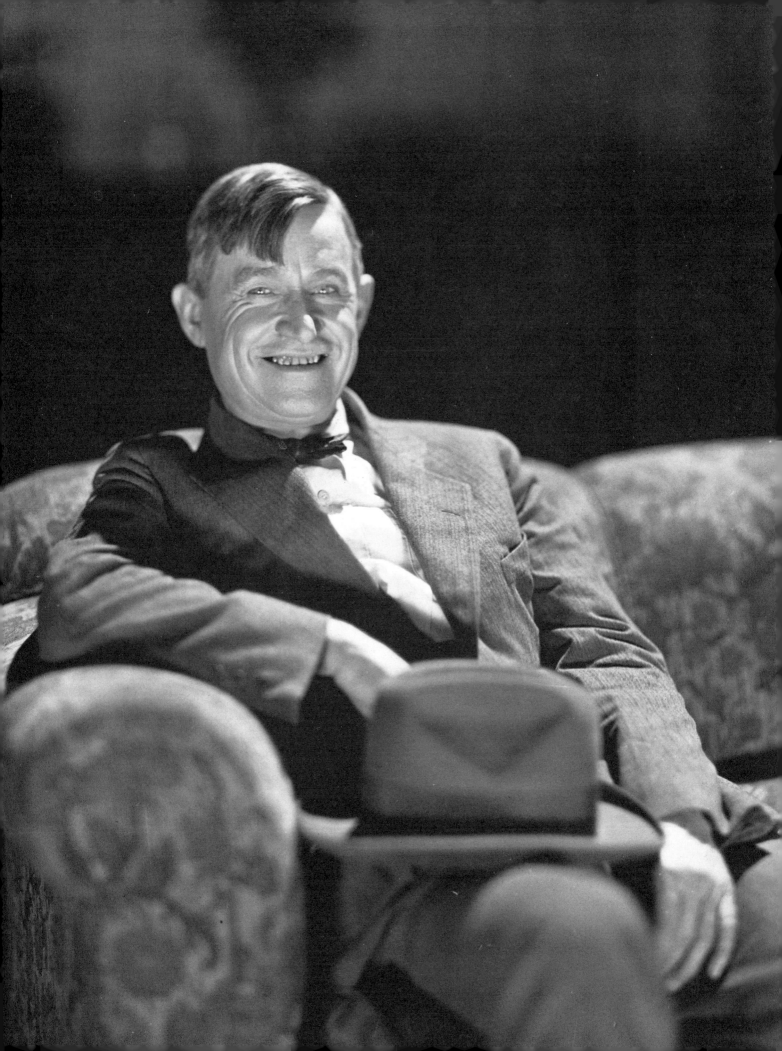

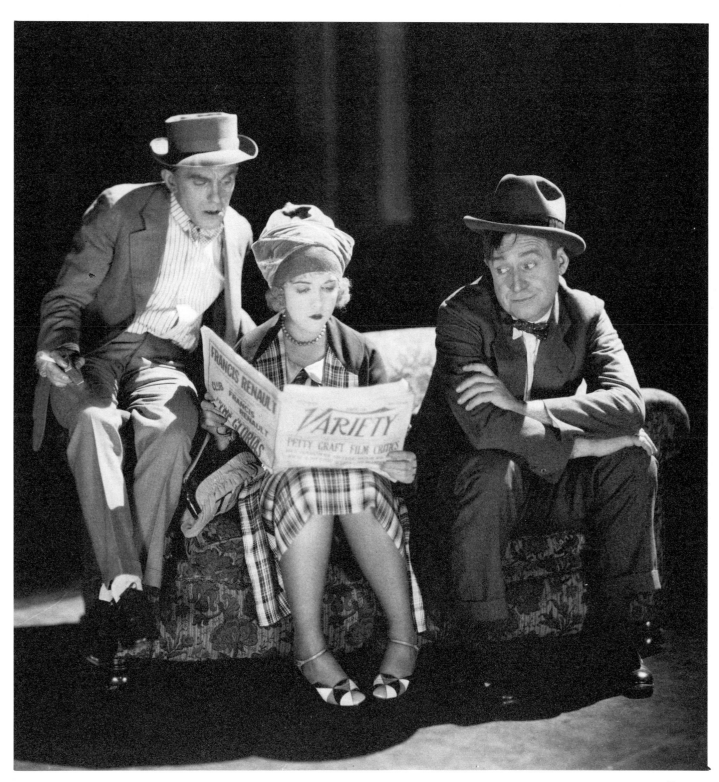

80 Nelson Keys, Dorothy Gish, Will Rogers

79 Will Rogers

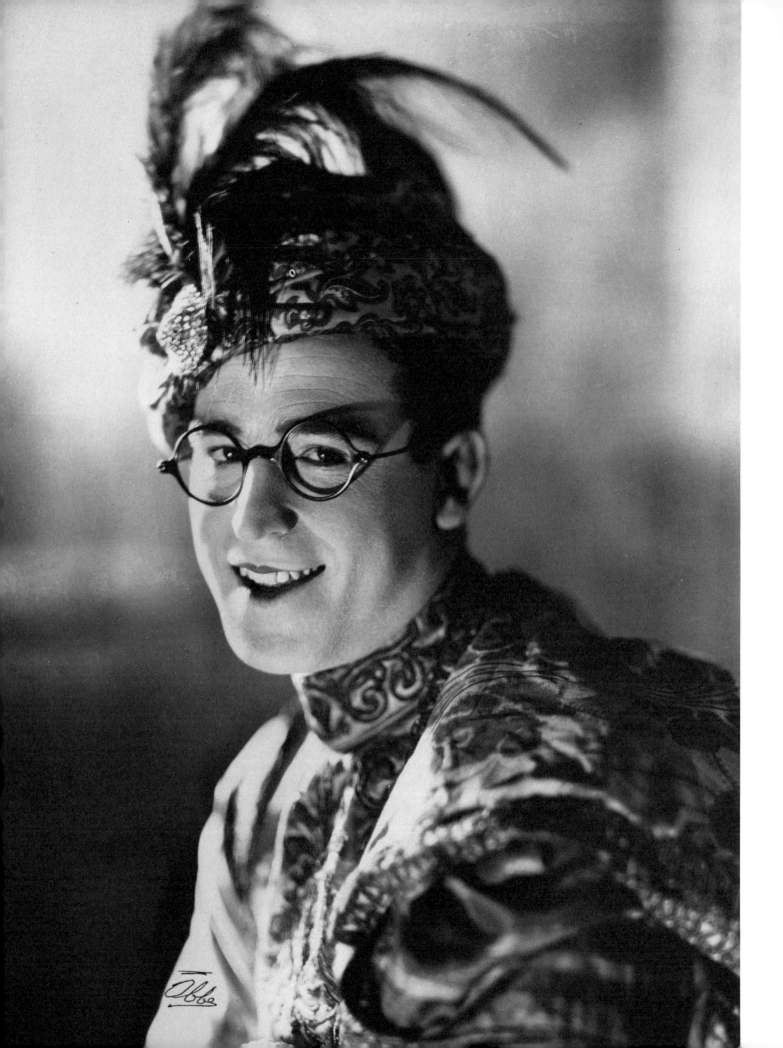

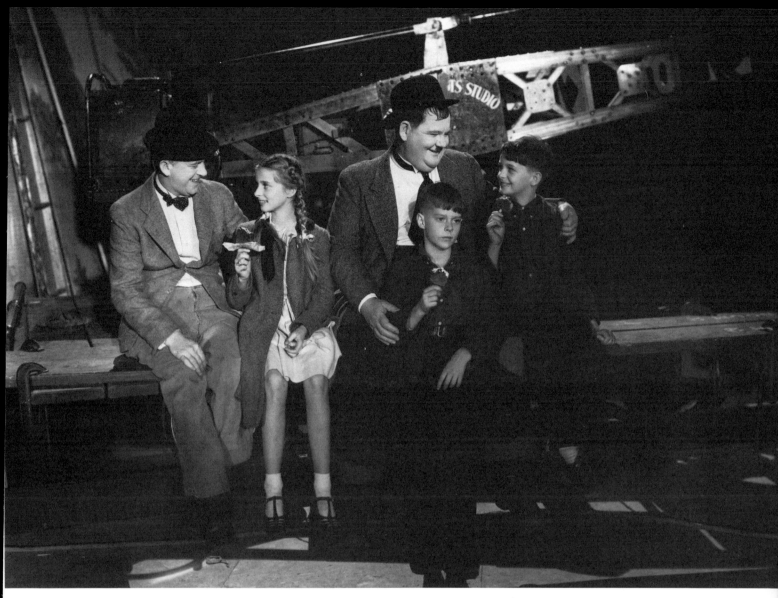

82 Laurel, Hardy, Patience Abbe, Richard Abbe, John Abbe

81 Harold Lloyd

83 Jackie Coogan

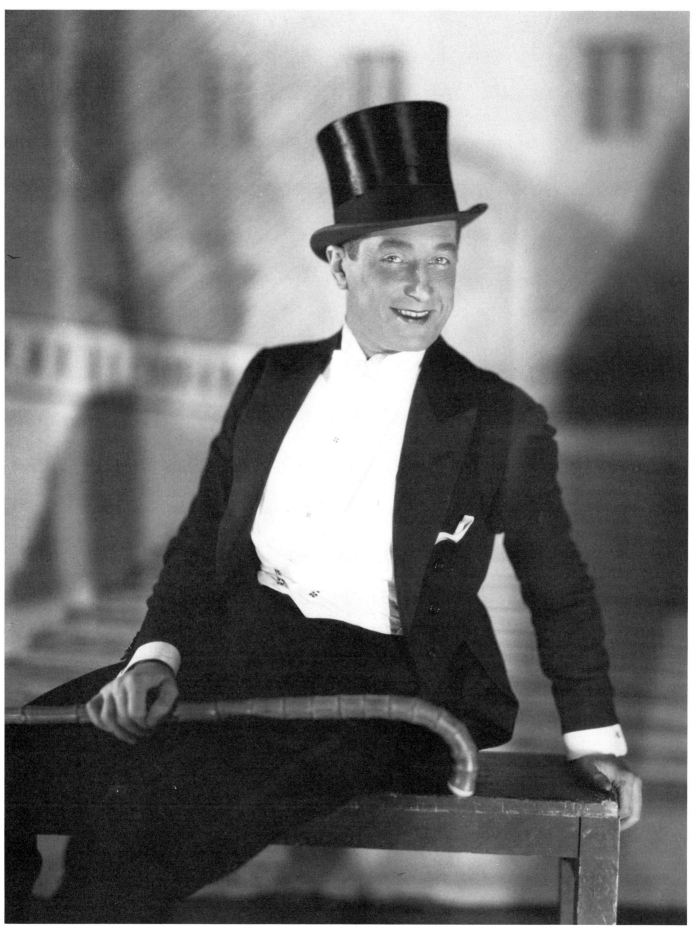

84 Maurice Chevalier

85 Mistinguett

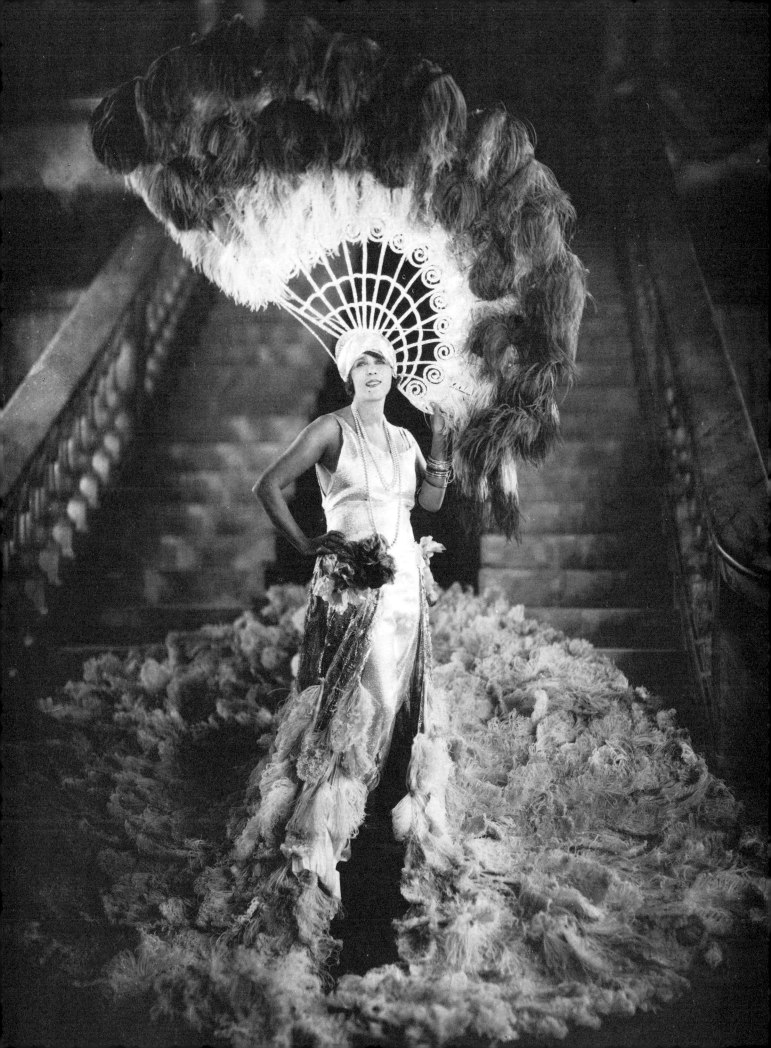

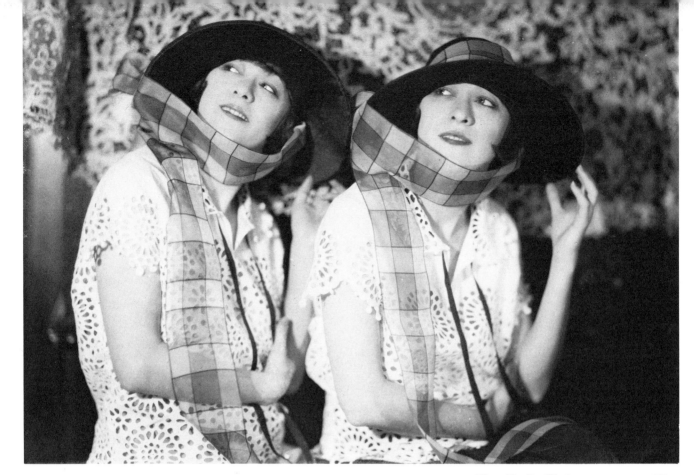

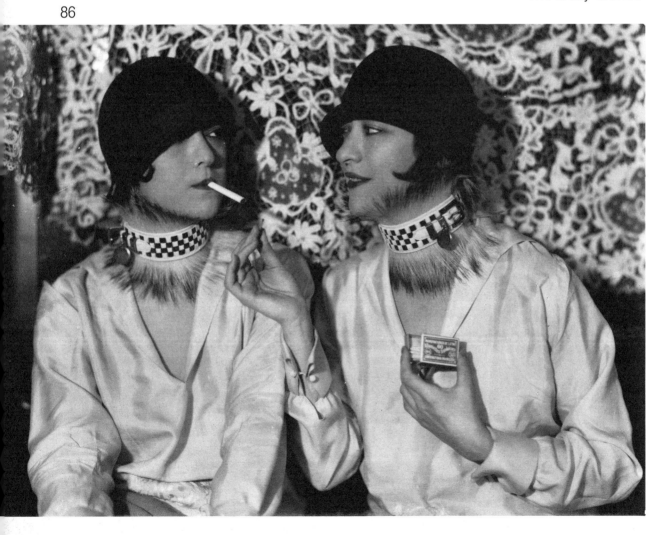

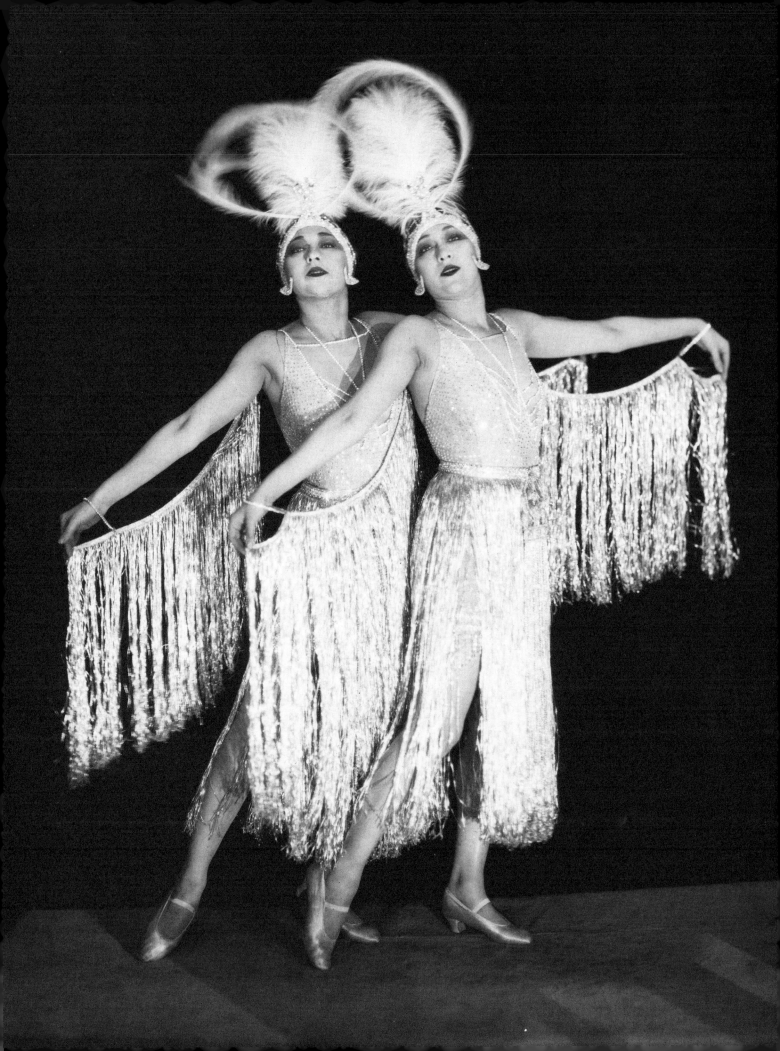

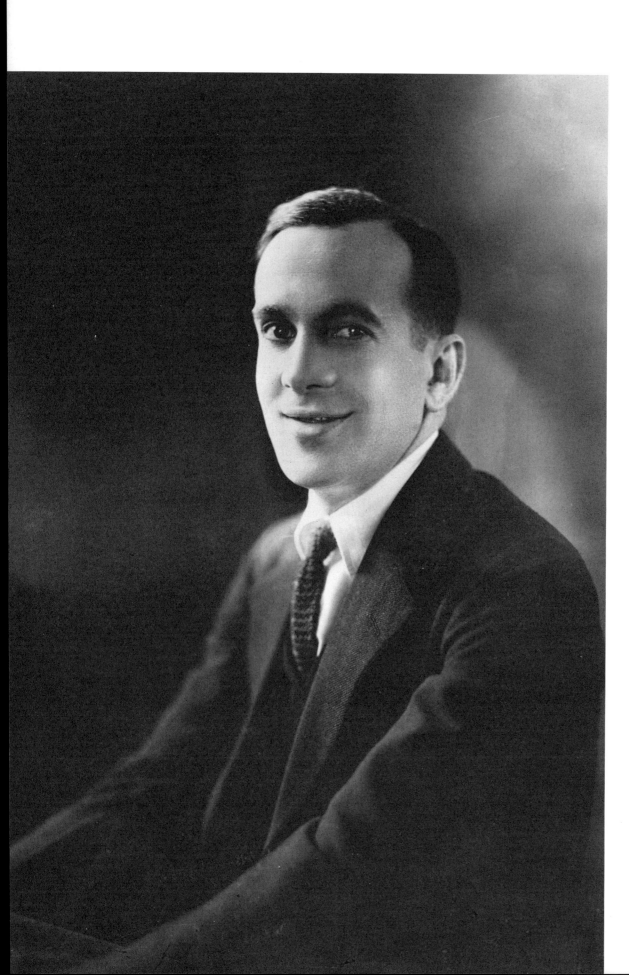

89 Al Jolson

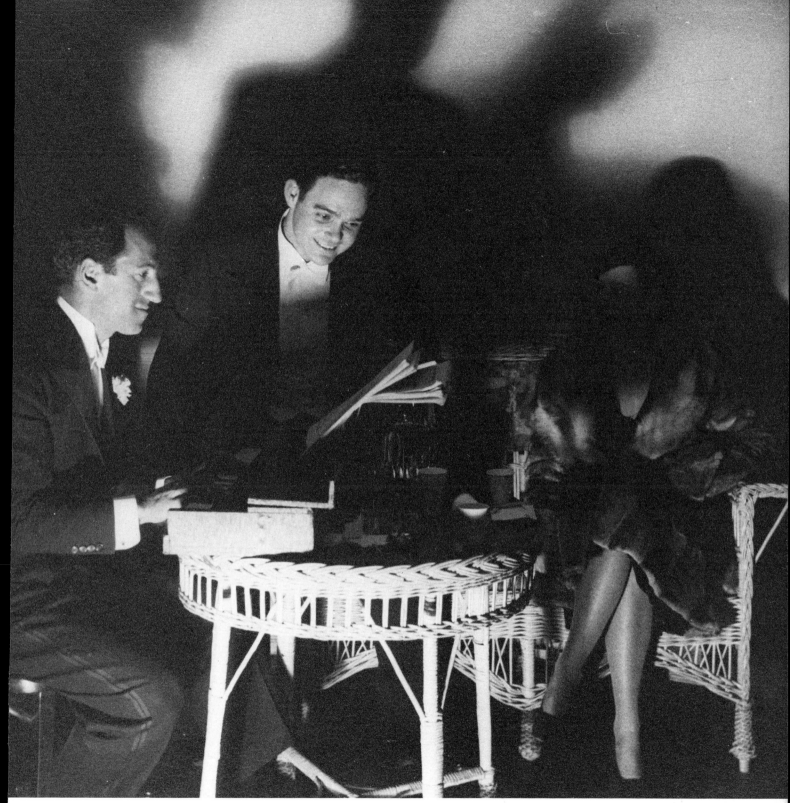

90 George Gershwin, James Melton

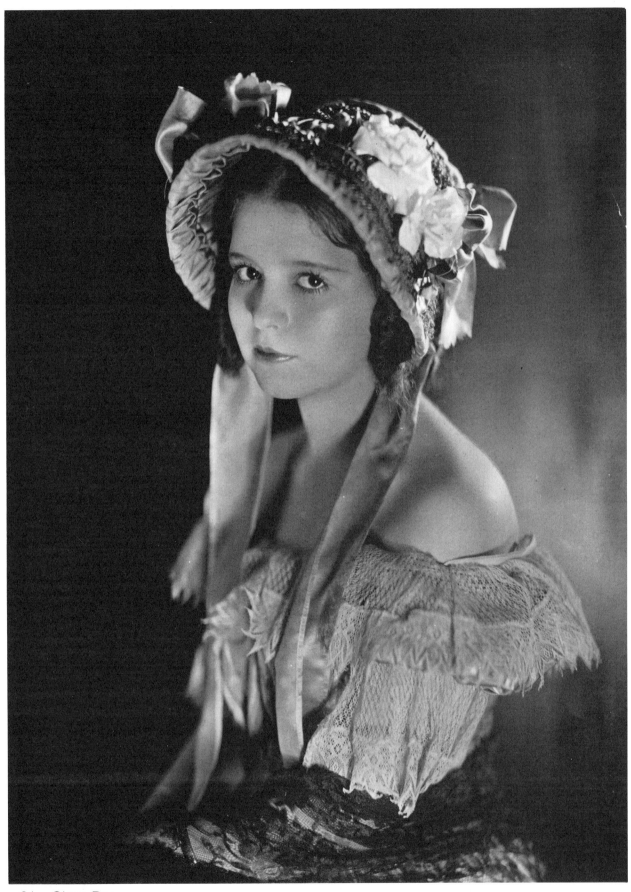

91 Clara Bow

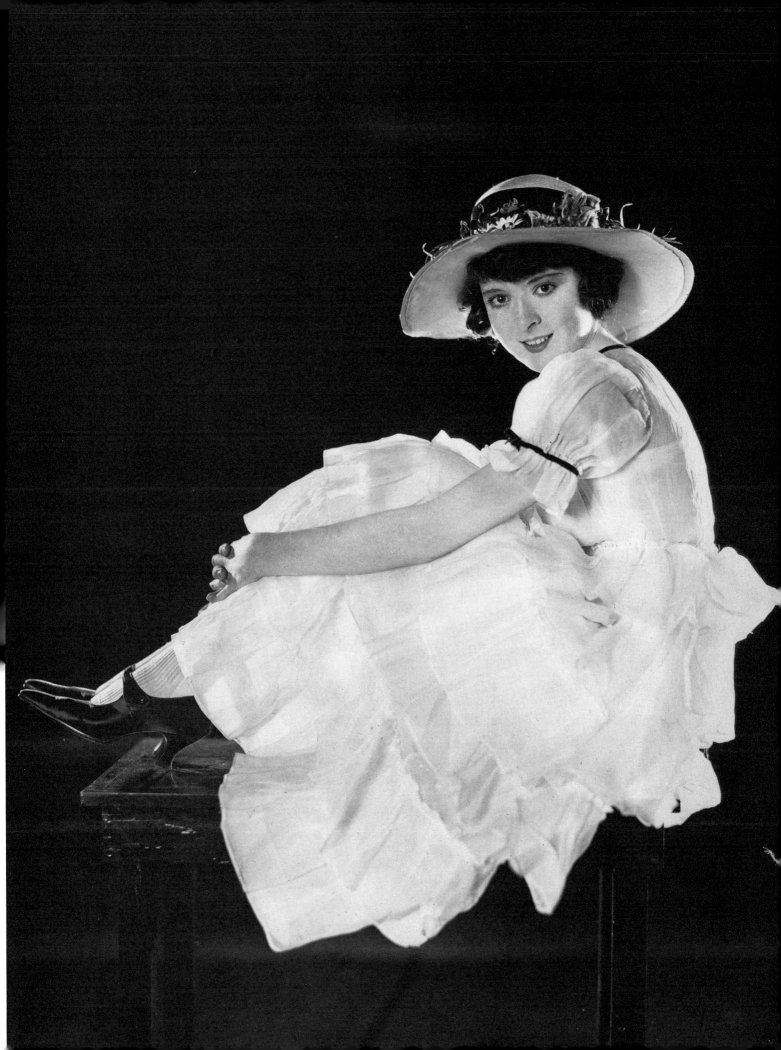

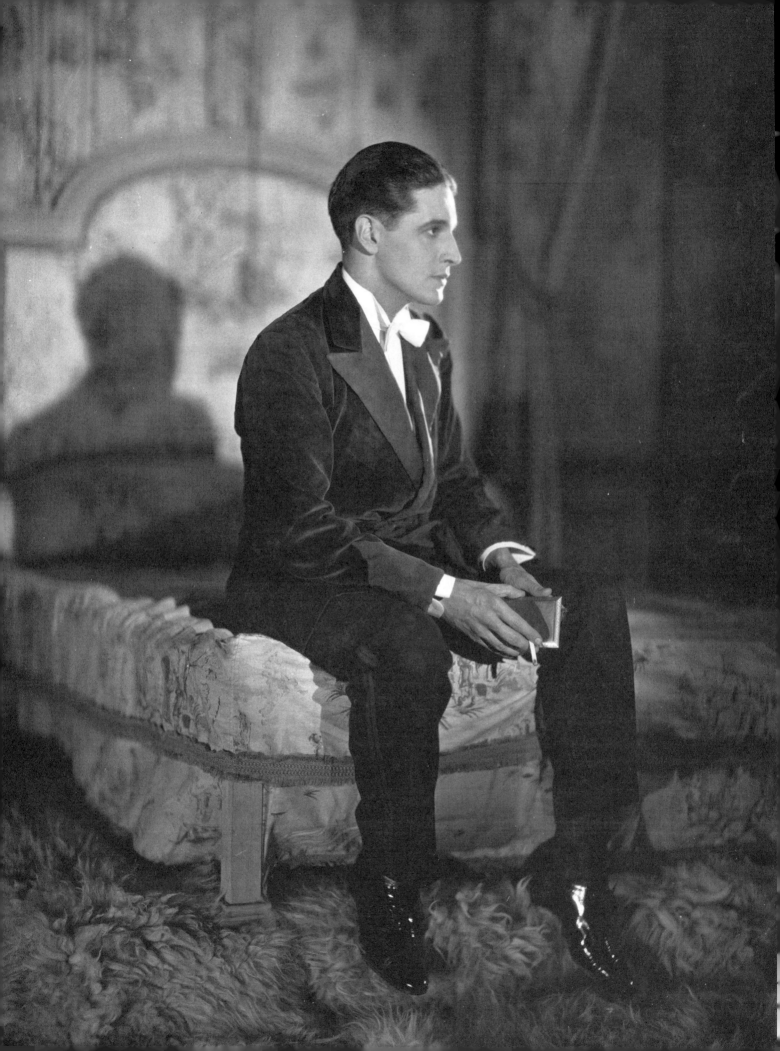

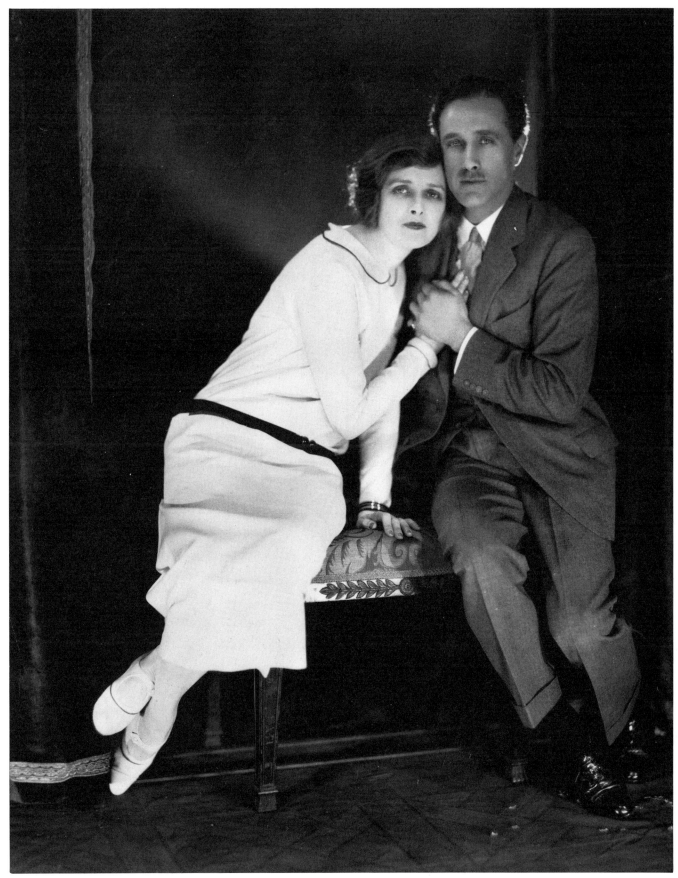

94 Gladys Cooper, Owen Nares

93 Ivor Novello

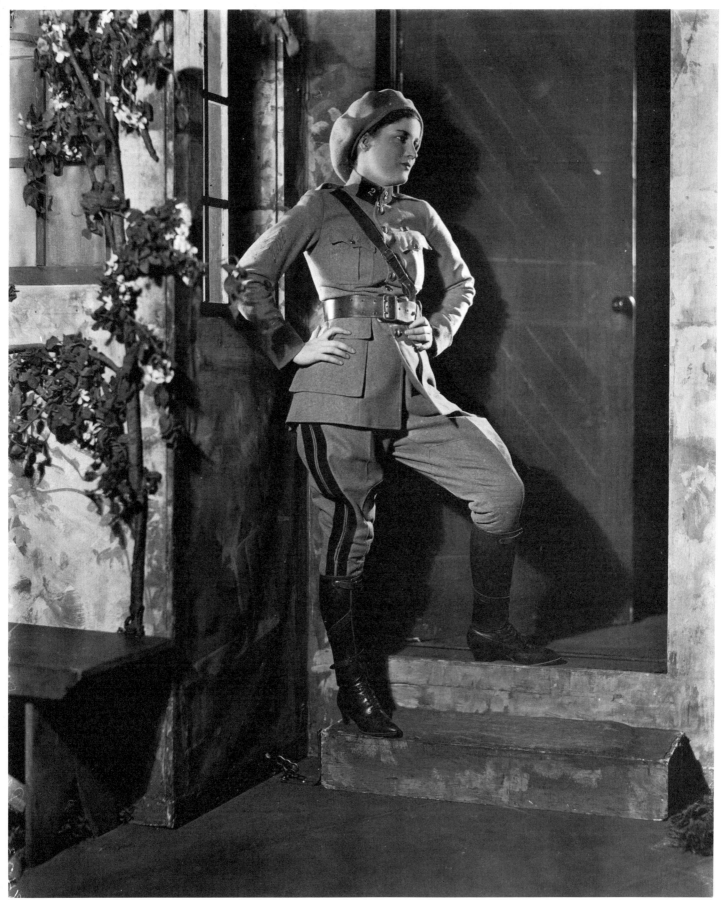

95 Peggy Wood

96 Agnes Ayres

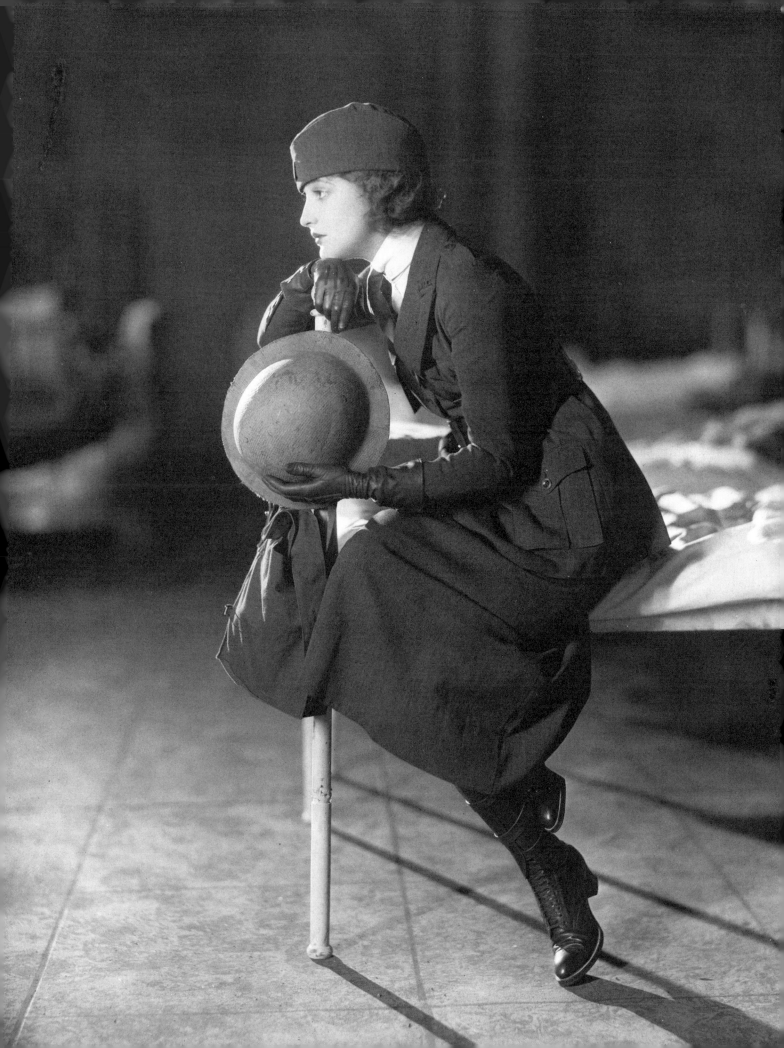

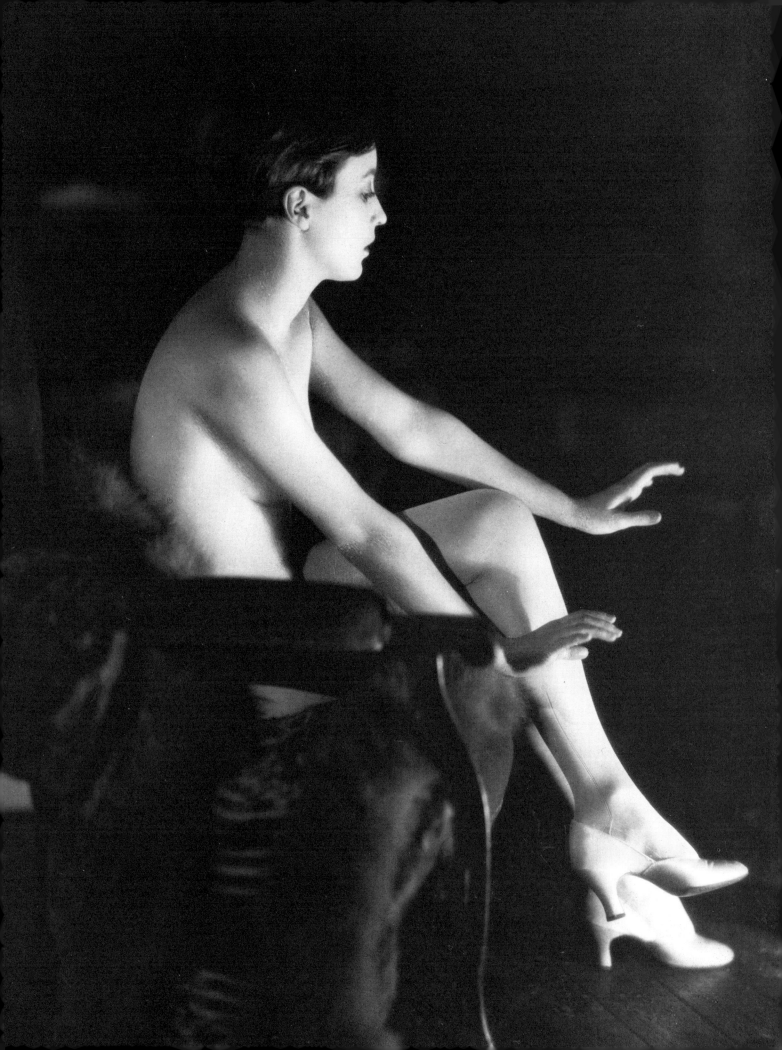

97 Bessie Love

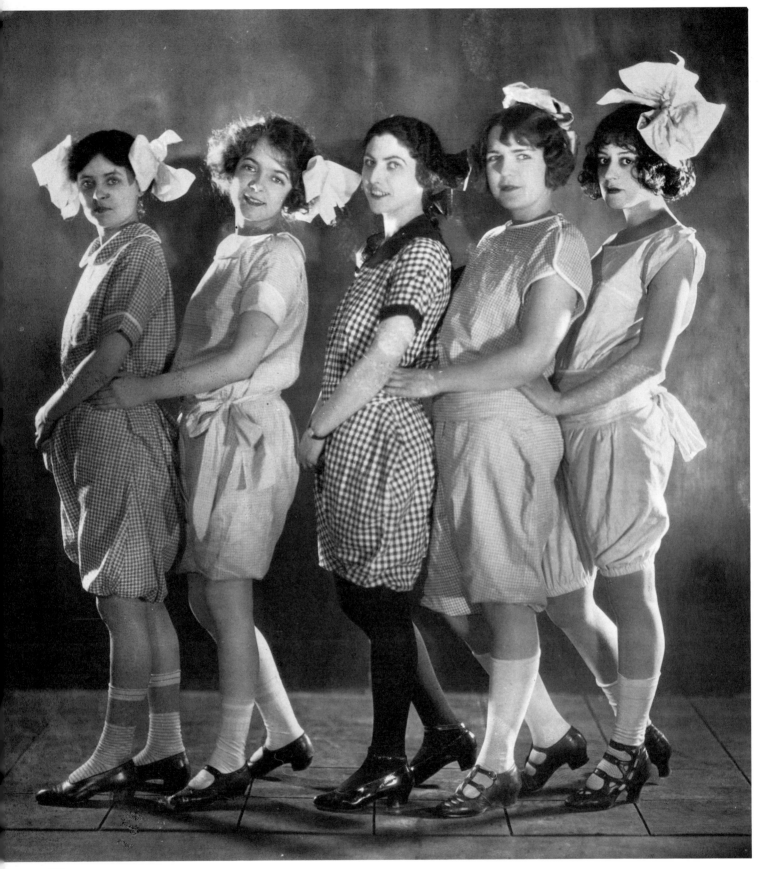

Helen Hayes

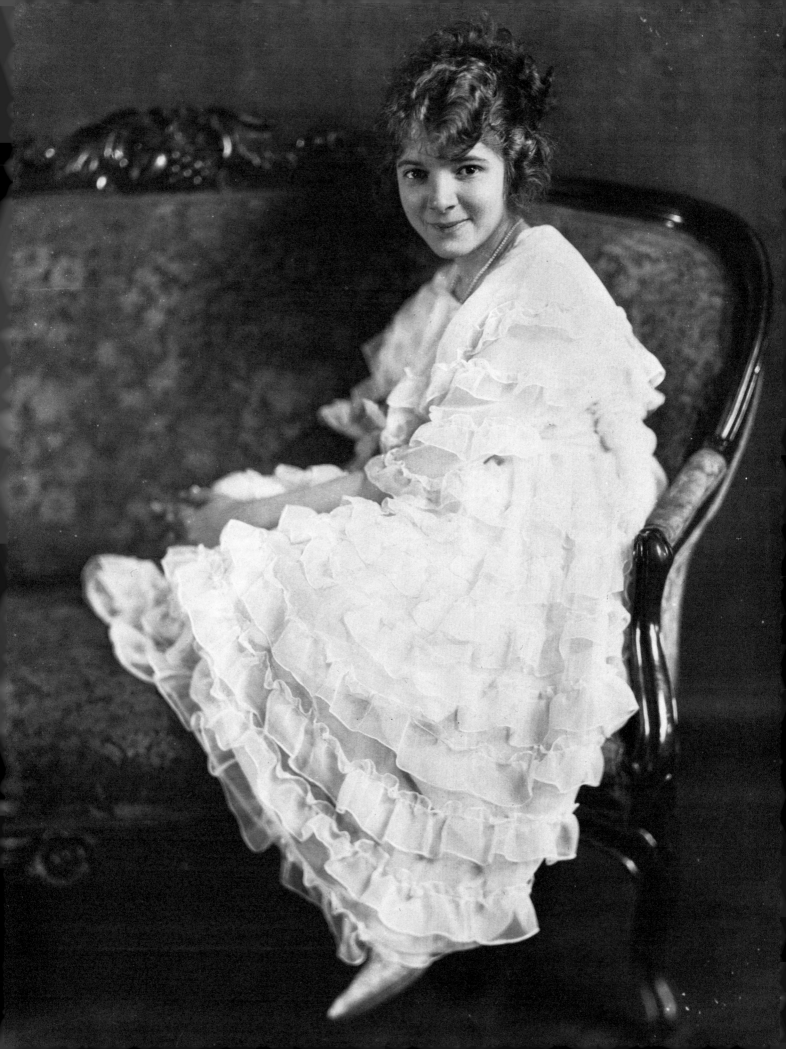

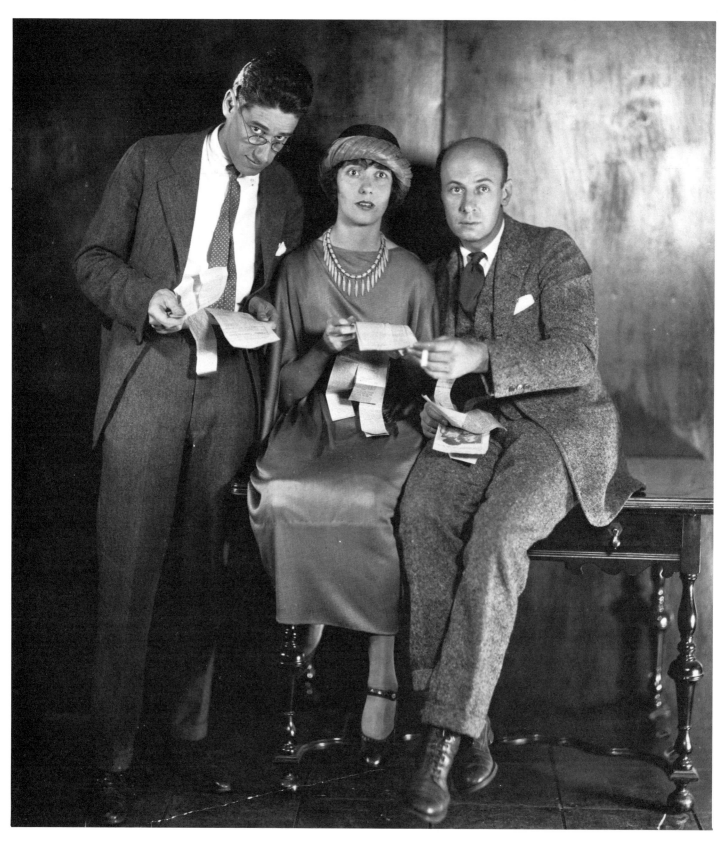

100 George S. Kaufman, Lynn Fontanne, Marc Connelly

101 Lynn Fontanne

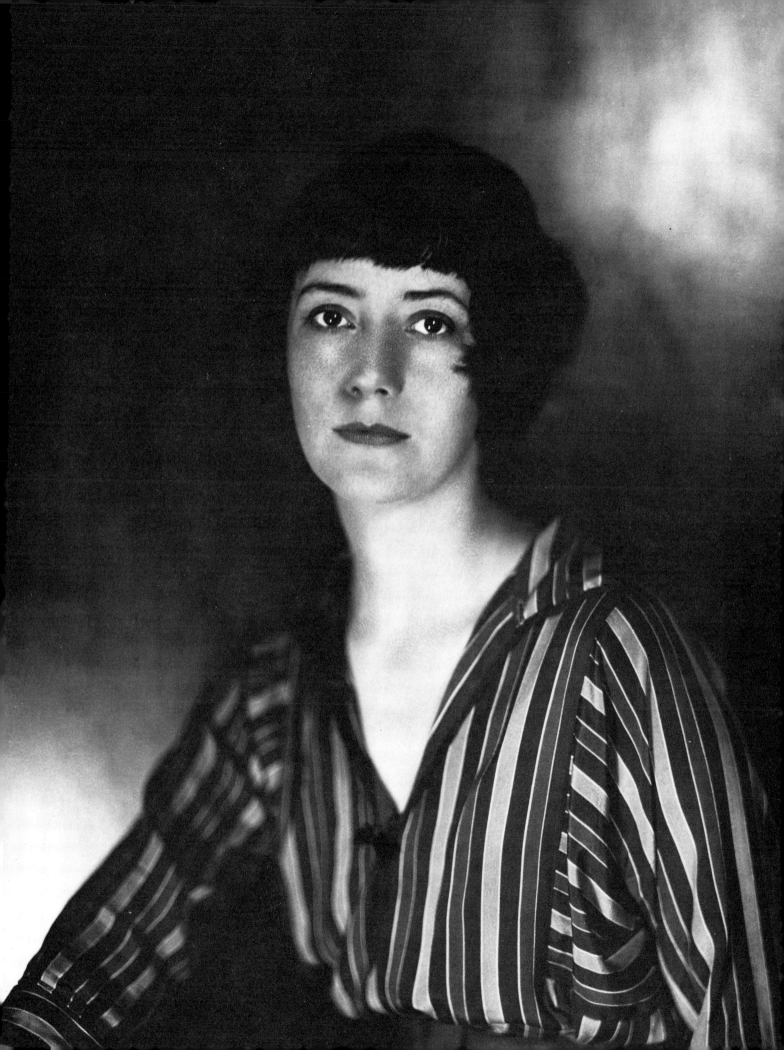

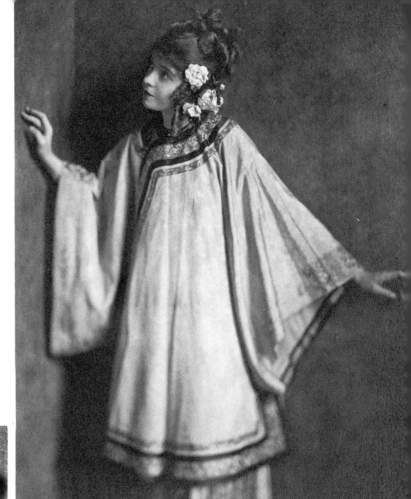

103

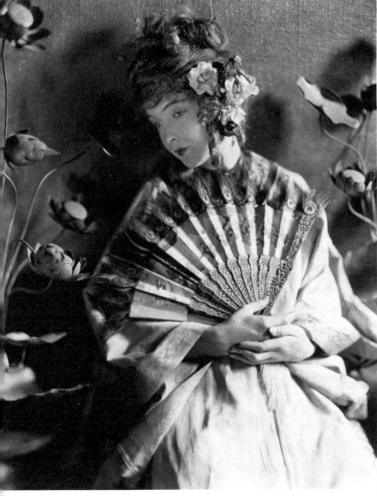

102

Lillian Gish

104

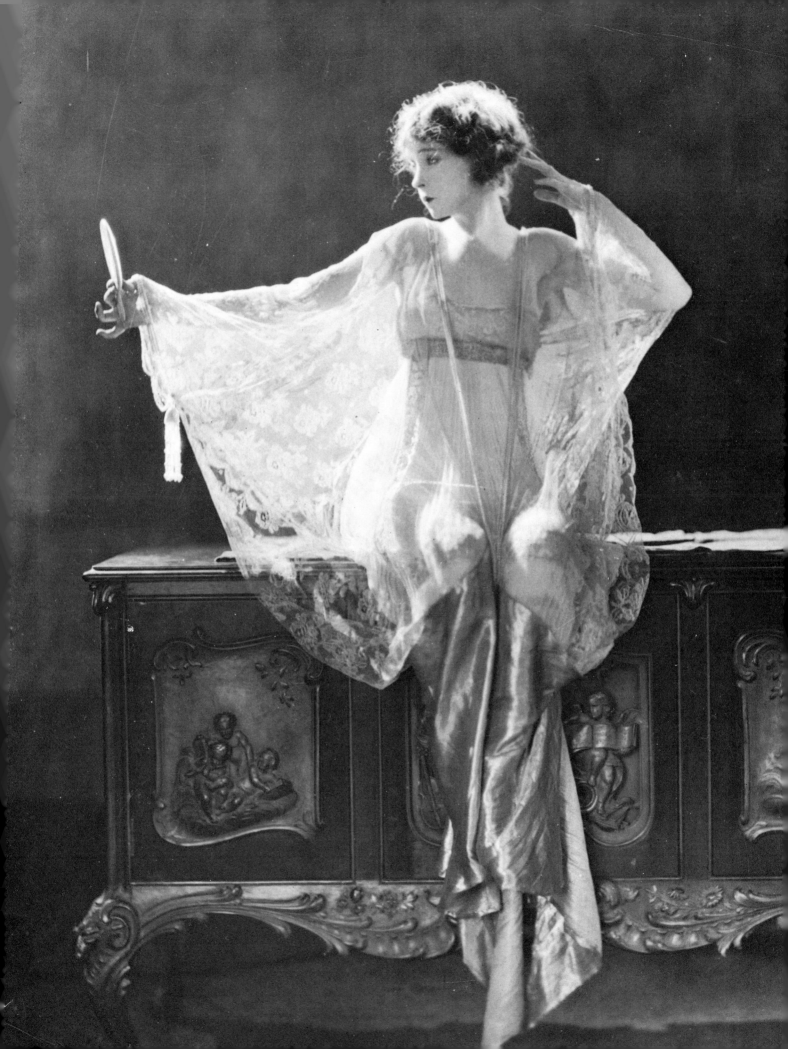

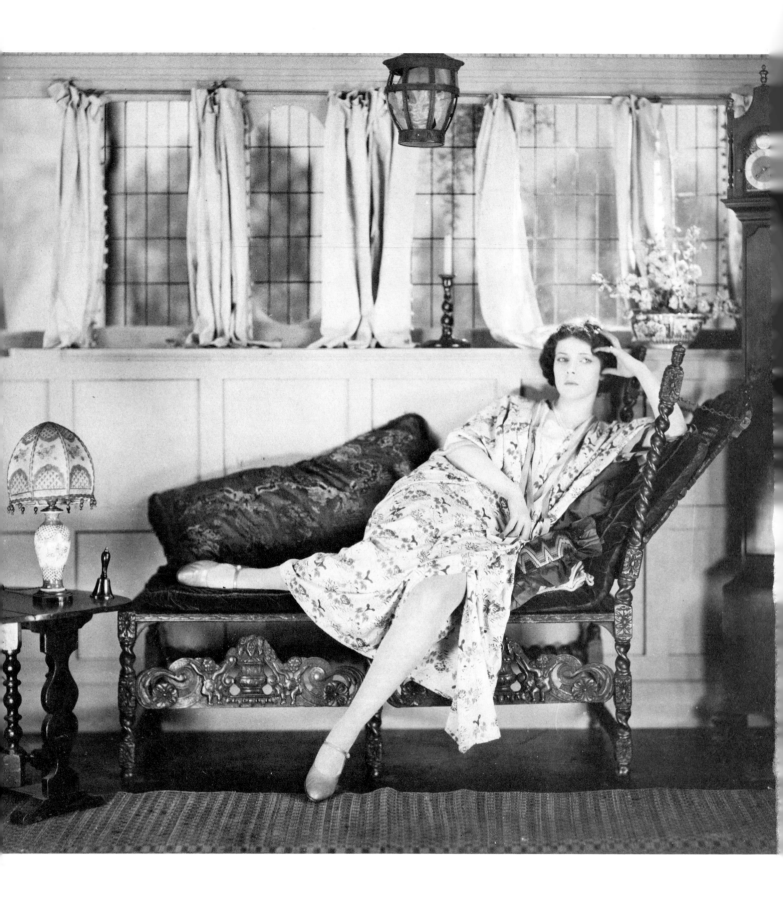

105 Elissa Landi